The Campus History Series

PRINCETON
UNIVERSITY

RICHARD D. SMITH

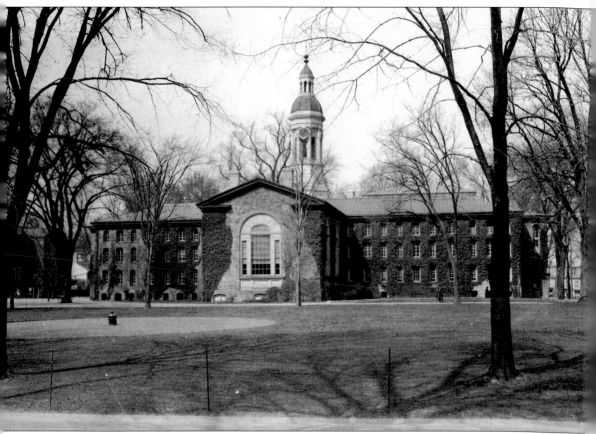

Nassau Hall and Cannon Green are the heart of the historic campus. The cannon, a leftover from the War for Independence, was taken to defend New Brunswick during the War of 1812. An 1835 attempt to bring it back to Princeton ended outside town with a broken wagon and the cannon's abandonment. Eventually, Leonard Jerome—member of the class of 1839 and grandfather of Winston Churchill—organized a massive and successful effort to return the hefty weapon to campus. It received its final emplacement behind Nassau Hall in 1840. (Historical Society of Princeton.)

The Campus History Series

PRINCETON
UNIVERSITY

RICHARD D. SMITH

ARCADIA

First published 2005

Published by Arcadia Publishing,
Charleston SC, Chicago IL, Portsmouth NH, San Francisco CA

Printed in Great Britain

Library of Congress Catalog Card Number: 2004101178

For all general information, contact Arcadia Publishing:
Telephone 843-853-2070
Fax 843-853-0044
E-mail sales@arcadiapublishing.com
For customer service and orders:
Toll-free 1-888-313-2665

Visit us on the Internet at www.arcadiapublishing.com

Dedicated to James L. Gould,
professor of Ecology & Evolutionary Biology, for his friendship
and for wonderfully widening my Princeton University experience.

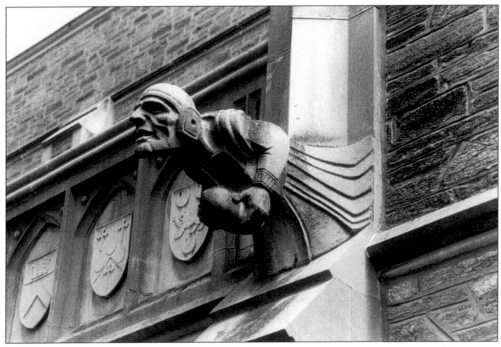

This carving of an old-time leather-headed football player greets visitors to Dillon Gym. (Richard D. Smith photograph.)

CONTENTS

ACKNOWLEDGMENTS

All photographs credited to the Princeton University Library are reproduced courtesy of the Princeton University Archives, Department of Rare Books and Special Collections, Princeton University Library.

This book would have been unlikely—indeed, impossible—without the help of the following: my admirably patient editor, Pam O'Neil; my copy editor, Maureen McDonald; Ben Primer of the Princeton University Library; Daniel J. Linke, Christine W. Kitto, Rosemary Switzer, and others from the university's Seeley G. Mudd Manuscript Library; the Historical Society of Princeton, especially the publications committee, and Gail Stern, Maureen Smyth, Laura Hughes, and other society staff friends; and the campus organizations and individuals who provided important images.

I have relied heavily on the work of many previous Princeton University historians, notably (but not limited to) *A Princeton Companion,* by Alexander Leitch; *Princeton University*, the campus architectural guide by Raymond P. Rhinehart; *Princeton University Profile 2003–04*, Princeton University Office of Communications, Alicia C. Brzycki, editor; Web site information by the Association of Black Princeton Alumni; and the research and writings of W. Frank Craven, Elizabeth Greenberg, Samuel C. Howell, David W. Hirst, Donald Marsden, Julie Rawe, Thomas Jefferson Wertenbaker, and Elizabeth Williamson. I am particularly grateful to Donald Marsden, Elizabeth Greenberg, and other members of the Princetoniana Committee for their encouragement and input.

As always in the course of my writing about Princeton town and campus, Wanda S. Gunning advised and corrected me on innumerable points. Any errors in this book are my fault, despite her best efforts.

Thanks also to Constance M. Greiff, Mary R. Guimond, Anne M. Daniel, Henry S. Horn, Toby Israel, Mae W. Smith, and in particular, Constance Carter, who now knows more about the book-writing process—and about authors—than she ever expected.

INTRODUCTION

No college has turned out better scholars or more estimable characters than Nassau.

—George Washington, writing in 1797 to his ward
George Washington Parke Custis, a student at Princeton.

Princeton University's history is, in many ways, the history of America. That is a sweeping statement, even grandiose. But in many ways it is true.

Both Princeton and America began with 18th-century idealists trying to create something of greatness and usefulness. In the 19th century, both experienced growth, crisis, and eventual renewal. Once children of the Old World, both matured into internationally respected leaders. In the 20th century, both rode the leading edges of research while also turning away from exclusivity and embracing diversity.

In all, the years have been kind to Princeton University. Its motto, *Dei Sub Numine Viget*, "Under God's Power She Flourishes," has proven prophetic.

Princeton appears eternal, its traditions seemingly carved of the very stones that substantiate its magnificent buildings. But like all great institutions or great nations, it simply gives the illusion of permanence.

Princeton has been ever changing.

The first president, Rev. Jonathan Dickinson, a Presbyterian minister, taught less than a dozen students in his home when the College of New Jersey commenced instruction in 1747. As historian Thomas Wertenbaker has written of Aaron Burr Sr. (the college's second president), for decades, he and his successors were "president, professor, secretary, librarian, purchasing agent all in one."

The current president, Dr. Shirley H. Tilghman, a molecular biologist, is the first woman to lead the school. In 2004–2005 (the latest academic year for which complete data is available), she administered 4,635 undergraduates and 1,975 graduate students. A total of 1,103 faculty (including lecturers and visitors) taught in 34 academic departments and 35 interdepartmental programs. An additional 5,291 employees worked on the 500-acre campus, in 160 buildings containing more than 8 million square feet of space.

By any measure—and in many polls—Princeton University ranks among the world's foremost institutions of higher learning. But it is not elitist; old stereotypes no longer apply. It is now a

coeducational school, in which minority students constitute about 30 percent of the undergraduates. And, as of this writing, 52 percent of all undergrads receive some kind of scholarship or financial aid.

They will undoubtedly give back to the university. One thing that does not change is the incredible devotion of Princeton graduates to "Old Nassau." It can be felt each spring during the amazing—indeed, unique—Princeton reunions. And it can be measured in alumni giving, now more than $35 million annually.

The first three chapters of *Princeton University* tell the story of this great enterprise, in basic chronology, from 1746 to just after World War II. The next three chapters consider the vital triumvirate of the arts, religion, and athletics. Then follows a section on traditions. The final chapter brings the university's history up to the present.

You may find some glaring omission in these pages: a beloved building or academic department unmentioned; a prominent president, professor, or graduate uncelebrated; a noteworthy event unrecalled; or a worthy student organization unpraised.

If so, please be forgiving. My subject is almost horizonless, but my canvas has been small.

One

THE BEGINNINGS
1746–1867

We got another student today.

—John Maclean Sr., professor,
ending a letter to a trustee in 1803.

Whom should we thank for Princeton University? The temptations of New York City? Voracious mosquitoes? A man named Belcher?

On October 22, 1746, a charter was granted in the name of King George II for a college "wherein Youth may be instructed in the Learned languages, and in the liberal Arts and Sciences." Opponents quickly challenged the charter on technicalities. But the new governor of the province of New Jersey colony, Jonathan Belcher, vowed to "do everything in my power to promote and Establish so noble an undertaking." He quickly issued a second charter and gave the school his 474-volume personal library.

The first classes were conducted in May 1747 in the manse of first president Rev. Jonathan Dickinson in Elizabeth, New Jersey. When Dickinson died suddenly, Rev. Aaron Burr Sr. succeeded him, and the school moved to Burr's residence in Newark. There were six students in the original graduating class of 1748.

Why did the College of New Jersey not stay put, to become (perhaps) Newark University?

Some say that the temptations presented by the nearby city of New York worried the original trustees. Others cite Newark's physical location near marshlands that in summer bred persecuting mosquitoes. But there was no question that the college needed to grow and therefore needed land. The trustees sought a new site.

The town to which the college moved in 1756 was on a geological rise and surrounded by verdant woods and abundant farmlands. Prince-town was one in a series of neighboring royally named villages along the King's Highway, including Kings-town (now Kingston) to the northeast; Queens-town, which once flourished near the intersection of today's Nassau and Harrison Streets; and even a Princess-ville, a few miles to the southwest. Princeton was ideally located as the midway stop on the stagecoach line between New York City and Philadelphia. And there was no other institution of higher learning located between Yale in New Haven, Connecticut, and William & Mary in Williamsburg, Virginia—a distance of nearly 400 miles.

Some prominent Princeton landowners provided 1,000 pounds for an endowment, along with four and a half acres of open land for the campus, and an additional 200 acres of woodland for fuel. Thus did Princeton win over its main rival, New Brunswick, which in 1766 became home to New Jersey's fine state college, Rutgers.

The College of New Jersey grew in reputation and survived the War for Independence, largely through the leadership of its sixth president, the great John Witherspoon. But many of his immediate successors had neither his vision, his energy, nor his resolve in a crisis. Enrollment declined drastically in the 1820s, from 148 to 66. Money was scarce, and student unrest was frequent.

By the 1850s, the college was finally turned around, but a new crisis soon arose for both the school and the nation. Due to its location, the College of New Jersey drew many young Southern men who did not wish to study farther away from home at Yale or Harvard. Their numbers at the college were considerable; in 1860, they made up almost a third of the 314 undergraduates. As the Civil War loomed, those students who opted to return home to fight for the Confederacy were allowed honorable withdrawal. Most were escorted to the train station by their Northern classmates amid emotional farewells.

Some 70 Princeton men died in the conflict. Some believe this number was equally divided between North and South. In any event, the College of New Jersey, like America, survived and healed to become stronger, and it awaited a new era.

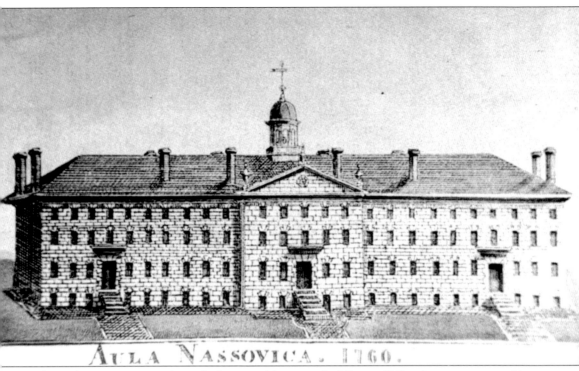

This 1760 engraving is perhaps the best surviving record of Nassau Hall as it was constructed in 1756 by Philadelphia carpenter-builder Robert Smith. It was the largest freestanding structure in the American Colonies at the time, holding the entire college, including student rooms. Nassau Hall's concept and design directly influenced the main buildings of numerous other 18th-century colleges. Like Princeton University itself, Nassau Hall has changed in significant ways while maintaining its essence. (Princeton University Library.)

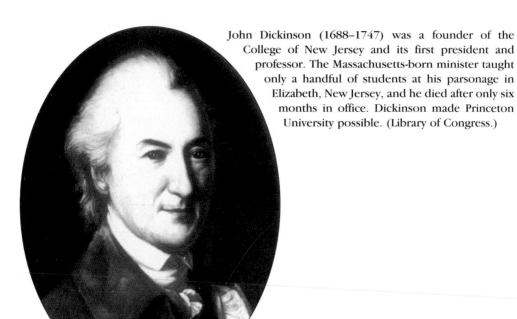

John Dickinson (1688–1747) was a founder of the College of New Jersey and its first president and professor. The Massachusetts-born minister taught only a handful of students at his parsonage in Elizabeth, New Jersey, and he died after only six months in office. Dickinson made Princeton University possible. (Library of Congress.)

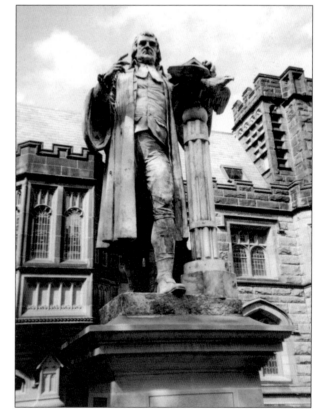

A cleric, writer, agriculturalist, and patriot, John Witherspoon (1723–1794) arrived from Scotland in 1768 to be the school's sixth president. He signed the Declaration of Independence, and after the Revolutionary War he labored to restore the college's fortunes. A man of no-frills expression, humanity, and dry humor, he was one of the school's great presidents. This statue depicting Witherspoon as preacher and orator was dedicated in 2001. (Richard D. Smith.)

The Rittenhouse Orrery, a seemingly quaint contraption, was once a state-of-the-art mechanism for modeling the known solar system. The college acquired the orrery from Philadelphia clockmaker David Rittenhouse in 1771, and it was upgraded in 1804 to reflect new findings in astronomy. After being exhibited at the 1893 Chicago World's Fair, the piece was thought lost until it was rediscovered in a crate in the McCosh Hall basement in 1948. The orrery was restored and displayed in the Department of Astrophysical Sciences in Peyton Hall. (Princeton University Library.)

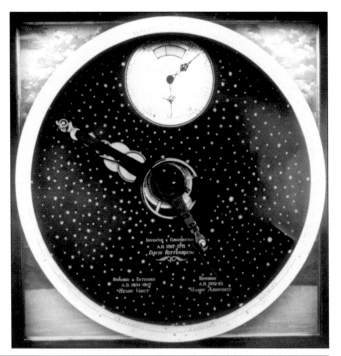

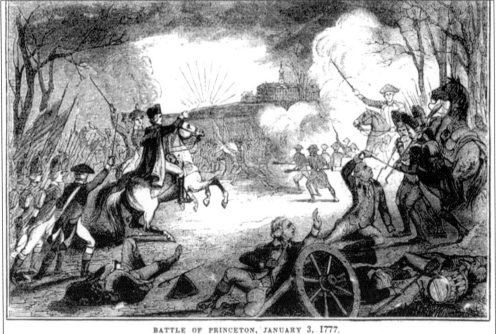

BATTLE OF PRINCETON, JANUARY 3, 1777.

George Washington did not intend to fight a Battle of Princeton. After his Trenton success, he hoped to quietly withdraw north to Somerville in the early morning hours of January 3, 1777. But a chance encounter outside Princeton with a British detachment led to the third decisive American victory in 10 days—a turning point in the Revolutionary War. This mid-19th-century illustration is fairly accurate: many redcoats were chased across open farmland to Nassau Hall (background), where they were surrounded and captured. (Library of Congress.)

Stanhope Hall, built in 1803, is the university's third-oldest surviving building (after Nassau Hall and MacLean House) and its most versatile. Stanhope has housed geological studies, a library, the college kitchen, the Philadelphia Society (as seen in this late-19th-century stereograph frame), and most recently, the Public Safety and Communications offices. Stanhope Hall's twin, Philosophical Hall, stood directly across Nassau Green until it was razed for the building of Chancellor Green Library. (Historical Society of Princeton.)

East College was Princeton's first true dormitory. It was erected in 1833, three years earlier than identical West College, across Cannon Green. Both were ventilated by eastward winds, unlike the often-sweltering student rooms in Nassau Hall. (Princeton University Library.)

The American Whig Society and the Cliosophic Society were contentious debating clubs. The original Clio Hall (shown here) and Whig Hall were built in 1838 of wood and stucco. These Greek Revival structures were prominently aligned on sidewalks running from Nassau Street. In 1893 the halls were rebuilt in stone, and their positions were moved inward to open sightlines through the campus. (Historical Society of Princeton.)

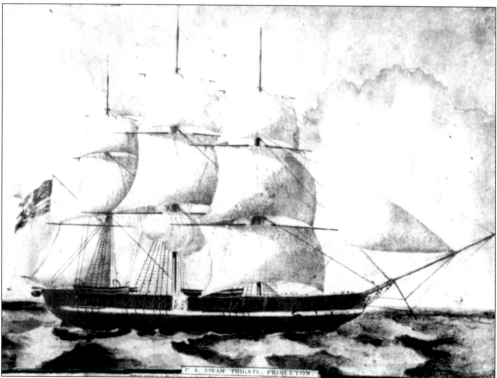

The sleek frigate USS *Princeton* was the first U.S. Navy vessel to be powered by a steam-driven screw. During an 1844 demonstration, a tragic cannon explosion killed the secretaries of state and navy, as well as other dignitaries. But five other *Princeton* ships have served America well in war and peace, most recently during the 1991 Gulf War. (Princeton University Library.)

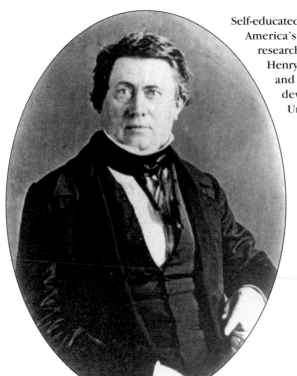

Self-educated Joseph Henry (1797–1878), one of America's great scientist-inventors, did early research in electromagnetism. A signal wire Henry created between Philosophical Hall and his home aided Samuel Morse in developing the telegraph. (Princeton University Library.)

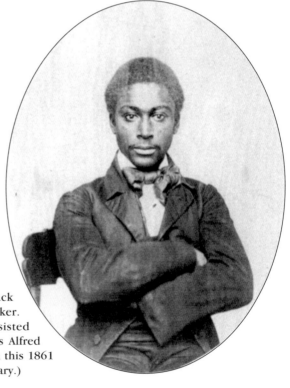

Professor Henry had a valued black laboratory assistant named Sam Parker. Another African American who assisted professors of "natural philosophy" was Alfred N. C. "Buck" Scudder, who is shown in this 1861 photograph. (Princeton University Library.)

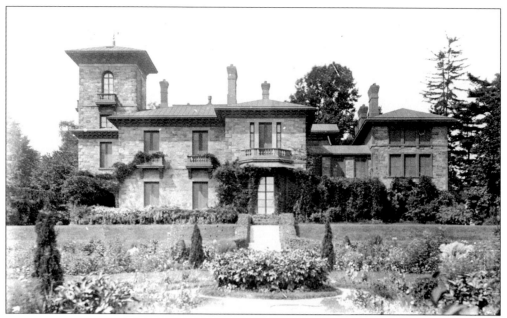

Built on a geological prominence, the house known as Prospect was so named because of its beautiful prospect or view of the southern flatlands. Its history goes back to Colonial times. This magnificent Italianate Revival home was built in 1850–1851. The property was donated to the college in 1878, and it served as the president's home until 1968. (Historical Society of Princeton.)

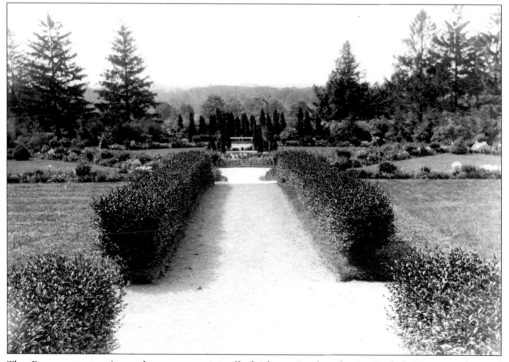

The Prospect estate's gardens were originally laid out in the classic English Manor style, and acquired their current appearance during a 1904 redesign. They are still lovingly maintained, a true gem of the campus. (Historical Society of Princeton.)

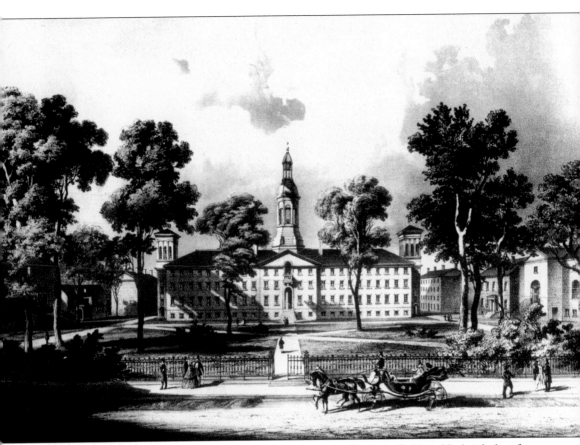

In 1756, the trustees were persuaded to build Nassau Hall not in fashionable brick, but from cheaper local sandstone, two feet thick. This decision helped Nassau's walls survive terrible fires in 1802 and 1855. After the second gutting, John Notman, architect of Prospect House, rebuilt "Old North" with its current large bell cupola, high-arched central entrance, and end stair towers, whose Florentine turrets were removed in 1906. (See Notman's south wing extension on page 24.) The embodiment of Princeton's permanence, Nassau Hall has actually been a developing work. (Princeton University Library.)

Although Woodrow Wilson failed to found a major law school at Princeton, there was a brief-lived one nevertheless. It opened in 1847 in a Mercer Street brownstone built by local attorney and early faculty member Richard S. Field in 1821. But the law school graduated only seven men, and the program was discontinued by 1854. The building is now owned by the adjacent Trinity Episcopal Church. (Historical Society of Princeton.)

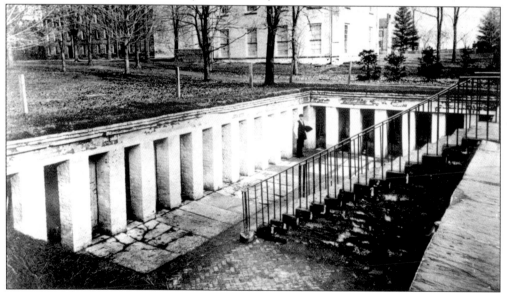

Large-scale outhouses (euphemistically known as "back campus buildings") once served the student body. Made of wood, they were frequently burned down. In 1861, the trustees built a facility of stone and brick in the ground. The Latin-learning undergrads quickly dubbed this monumental 28-stall privy the "cloaca maxima," after the great sewer of ancient Rome. It was filled in after 1880 as the campus expanded around it and indoor plumbing became the norm. (Princeton University Library.)

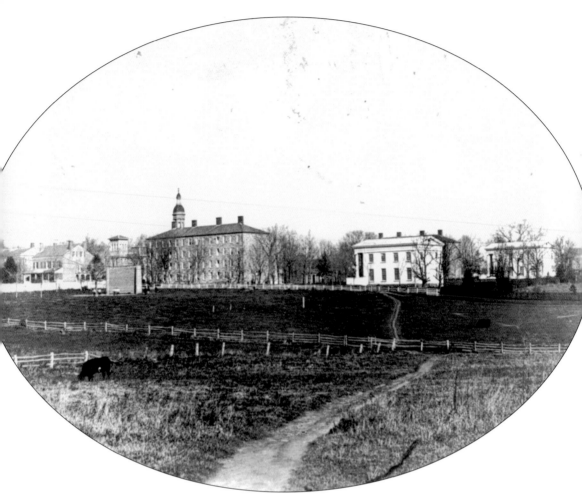

Cows graze contentedly in the late 1860s near the college's athletic fields. West College dormitory dominates the background, along with the original Clio and Whig Halls. Much changed in the years that followed. (Princeton University Library.)

Two

BUILDING A
TRUE COLLEGE
1868–1910

*With a massive but spare frame which, when his mind is roused,
abandons its scholarly stoop and towers above expectation . . . the broad
forehead and keen eyes bring into prominence his well-known capacity
for an impetuous, unyielding, intellectual onset.*

—John van Cleve describing James McCosh
in *The Century*, February 1887.

Princeton achieved much of its current character immediately after the Civil War and before World War I. It was a period of great campus building in the physical sense. But major academic departments were also formed, teaching systems refined, and philosophies defined. Truly, the mortarboard kept pace with bricks and mortar.

The vision and zeal of 11th president James McCosh set the College of New Jersey on the path to becoming the great university it is today. In 1870, two years after he took charge, the school had 23 buildings, 21 faculty, and 328 undergraduates. By the time he retired in 1889, the institution had grown to 30 buildings, 43 faculty, and 652 undergraduates. Under McCosh, the college built its first freestanding library, all-academic building, and gymnasium, and granted its first official doctoral degrees.

McCosh should also be remembered for his droll sense of humor.

On Halloween night in 1887, student pranksters hauled McCosh's carriage to a farmyard near Kingston. As they turned to leave, they were startled by the president (hidden inside the vehicle) wryly announcing: "Thanks so much for the ride, boys. Now, if you will, please drive me home again."

And one morning at chapel, after McCosh had published a successful new tome, he began his prayer, "Oh Thou, who has also written a book . . ."

Despite its growth, the college retained an 18th-century quaintness. McCosh's successor, Francis Landey Patton, ran the entire college from the study of Prospect House, and had no secretary until 1895. Indeed, there was no official university secretary until the end of 1900.

The era's other giant was, of course, Woodrow Wilson, the college's 13th president. Some historians associate his Princeton years with a few glorious failures: his attempts to establish a law school, locate the Graduate School within the main campus, and banish the eating clubs. Instead, Wilson should be recalled for his successes: his progressive academic policies, reorganization of the school, and overall leadership.

But it is not just buildings or programs that define this period. It is the land itself.

In 1889, the Potter Farm, a tract of woods and meadowlands extending from below Prospect House to the Delaware and Raritan Canal, was presented to the college by the estate of the late John C. Green. This 155-acre expanse suddenly quadrupled the area of the campus. As Moses Taylor Pyne, the visionary chairman of the grounds and building committee, told his fellow trustees, "This magnificent gift preserves forever our beautiful view, and leaves ample room for the growth of the university for many years to come."

Pyne further declared that Princeton now had "the finest Campus of any college in America." No one disputed him.

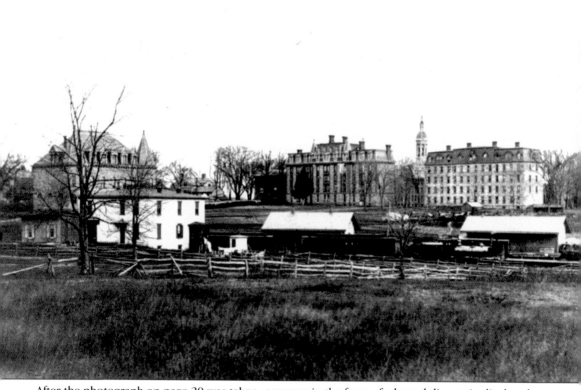

After the photograph on page 20 was taken, progress in the form of a branch-line train displaced cows in the west campus. Next to West College (far right, middle) rose a new dormitory, Reunion Hall (center), built in 1870. Farther to the west was the Bonner-Marquand Gymnasium (far left, middle), completed the same year. (Princeton University Library.)

After the terrible 1855 fire in Nassau Hall, John Notman extended the former chapel to create a suitable space for the college library. With the creation of Chancellor Green Library, a new use was found for this south wing (as pictured below). (Historical Society of Princeton.)

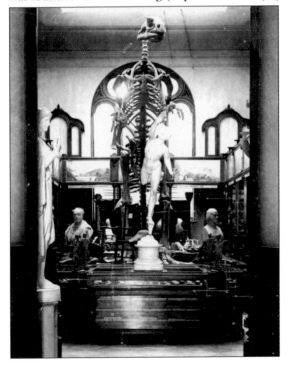

What is today the faculty room was at one time a general museum of natural history and art. The museum existed between 1873 and 1906, and was set up by Benjamin Waterhouse Hawkins, the English artist who made the first serious reconstructions of prehistoric animals. (Historical Society of Princeton.)

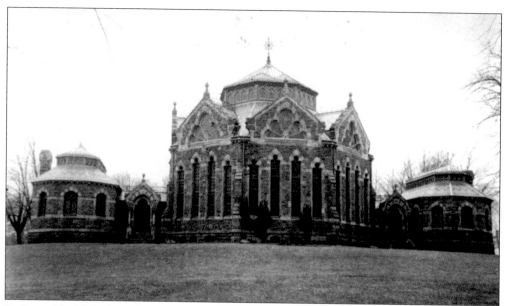

Dedicated in 1873, the splendid Chancellor Green Library held a total of 72,000 volumes and had wing rooms for art (left) and the faculty (right). After the construction of Firestone Library in the late 1940s, this building was wisely converted into a student center. A recent renovation has restored Chancellor Green to its full glory. (Princeton University Library.)

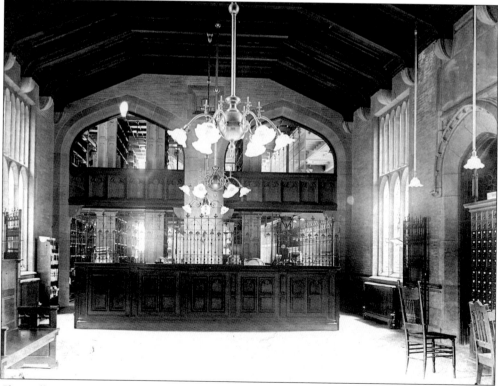

Chancellor Green Library's delivery desk sits amidst the spectacular Ruskinian Gothic architecture designed by famed architect William A. Potter. (Historical Society of Princeton.)

Construction of an astronomy building had been planned before the Civil War. Finally, in 1869, the Halstead Observatory was built on Railroad Avenue (now University Place) through the gift of Gen. Nathaniel Halstead. Important observations were made through its telescope before the building was razed in 1930 to make way for Joline Hall. (Princeton University Library.)

Late-19th-century Cannon Green featured the college's first freestanding chapel (see chapter 5). In the left foreground, Jimmy Johnson stands waiting to sell snacks of fruits and nuts to passing students. Johnson was a former slave who found freedom, popularity, and success in Princeton. (Princeton University Library.)

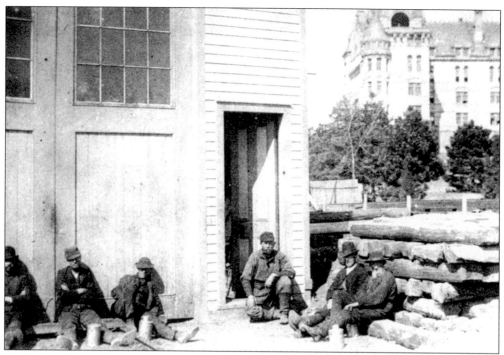

Workmen take a well-deserved break in the late 1870s. In the background is Witherspoon Hall, then considered a luxury dormitory. (Princeton University Library.)

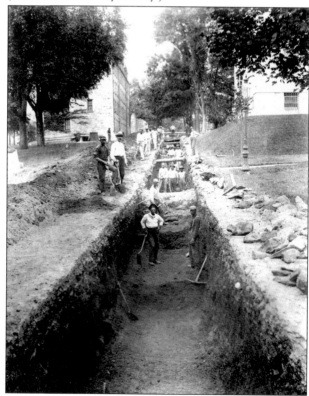

A serious trench between West College and Clio Hall (right) reminds us that campus maintenance has been an ongoing—almost traditional—process. (Historical Society of Princeton.)

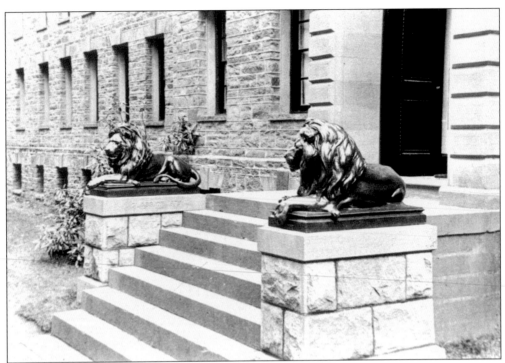

Lions, symbols of wisdom, were given by the class of 1879 (which included Woodrow Wilson) to guard Nassau Hall. In 1911, the same class replaced them with the present tigers, by then fiercely established as Princeton's symbol. Today, the lions regally recline near Wilcox Hall. (Princeton University Library.)

This wicked mid-19th-century, student-made collage satirized James McCosh (at the head of the table on the right) and his faculty as hard-drinking, heavy-smoking, card-playing carousers. (Princeton University Library.)

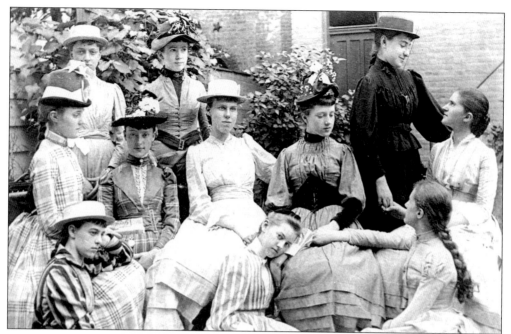

Evelyn College was founded in 1887 in hopes of becoming the university's official women's school. It had a serious curriculum, and was largely attended by relatives of Princeton professors and students. A national recession and the death of founder Joshua Hall McIlvaine, class of 1837, ended this noble experiment in 1897. Evelyn College's main building still exists on Evelyn Place, west of the Nassau-Harrison Street intersection. (Historical Society of Princeton.)

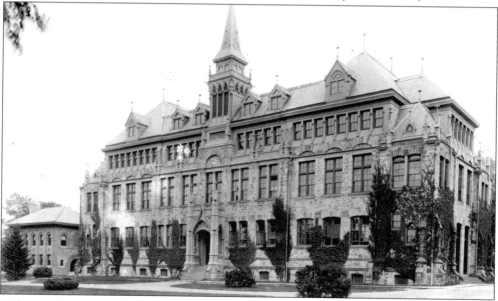

Dickinson Hall was a mansard-crowned showpiece of President McCosh's ambitious building program. Prior to its 1870 construction, no campus building had existed solely for academics. Dickinson stood on the site of today's Firestone Library, and featured a large recitation room (exam hall) on the top floor. A 1920 fire in Dickinson destroyed that building and the adjacent Marquand Chapel. (Historical Society of Princeton.)

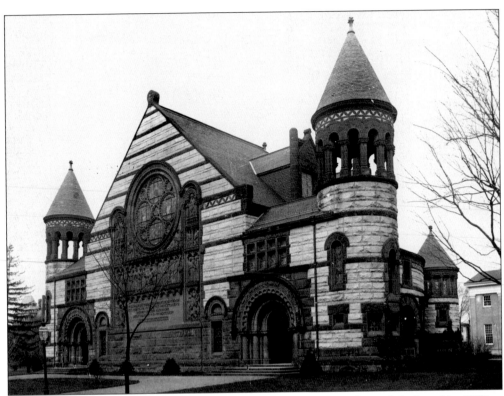

Built in 1892, Alexander Hall was given by Harriet Crocker Alexander and designed by William Potter (architect of Chancellor Green and East Pyne) to fill the need for a major assembly hall. The myth that it was the failed undergraduate project of a wealthy (and vengeful) alumnus probably arose because the front of the building (facing Nassau Street) seems poorly conceived. But the true front façade is on the campus side, its entrances once served by a circular driveway. (Historical Society of Princeton.)

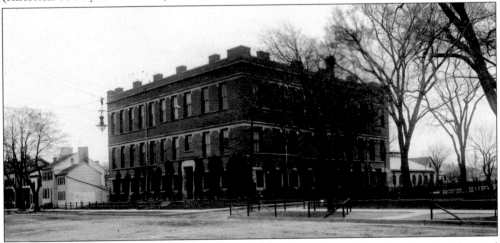

Contemporary with Alexander Hall, yet totally dissimilar in style and function, was the Chemical Laboratory of 1891 (now Aaron Burr Hall). This battlement-bedecked fortress of research, at the corner of Nassau and Washington Streets, was built before the town of Princeton had traffic lights or even paved streets. (Historical Society of Princeton.)

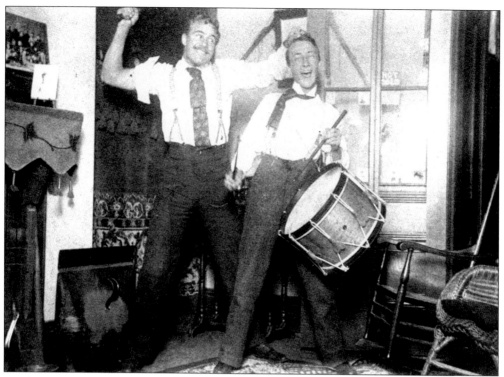

Breaking the peace to get some quiet, Charles MacKenzie (left), class of 1894, applies his own percussion to his roommate William Thomson, class of 1896, in this gag shot. (Princeton University Library.)

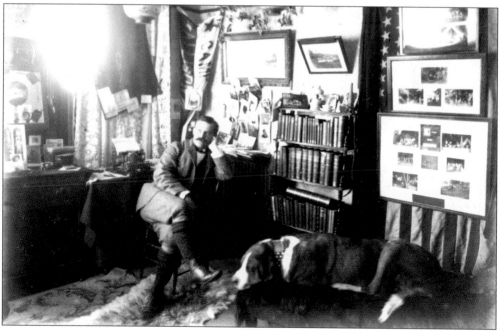

Cozy clutter cheers the room of a reflective Robert J. Deck and his dog, Don, in 1897 at Easton House, located at 47 University Place. (Historical Society of Princeton.)

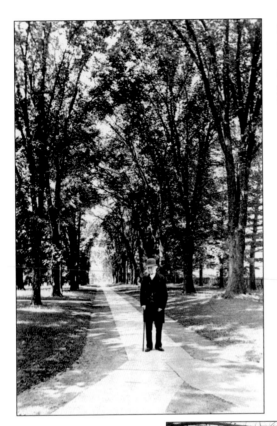

In retirement, James McCosh strolled a tree-lined route (now known as McCosh Walk) and looked about him. "It's me college," he once told a visitor, proudly yet accurately. "I built it!" (Princeton University Library.)

James McCosh died in 1894 and did not see these triumphal wooden arches constructed two years later on Nassau Street to celebrate the school's 150th anniversary. But the change of the College of New Jersey's name to Princeton University had been long expected. (Historical Society of Princeton.)

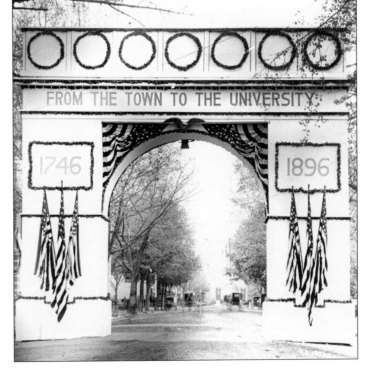

FROM THE TOWN TO THE UNIVERSITY

1746

1896

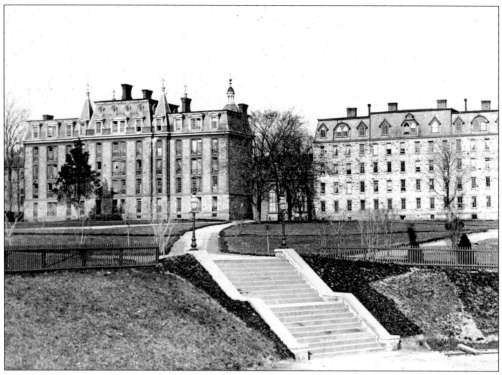

Disembarking at the Princeton train station in the 1870s, visitors were greeted by stone steps, a modest wood fence, gaslights, and Reunion Hall (left) and West College in a park-like expanse. The rise was soon crowned with that most regal example of collegiate Gothic architecture, Blair Hall. (Historical Society of Princeton.)

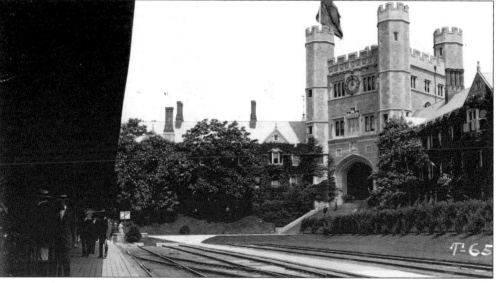

Luxuriously ivied in this view, Blair Hall was designed so that train travelers would enter the university campus through a monumental castle gateway. It was not until after 1918, when the station was moved to make room for new buildings, that FitzRandolph Gate on Nassau Street was considered the main campus entrance. (Princeton University Library.)

Thomas Woodrow Wilson (1856–1924) was the 13th president of Princeton and the first non-cleric to hold the position. (However, his father was a Presbyterian minister.) A member of the class of 1879, he was among the first Virginians to return to Princeton after the Civil War. Hired as a professor in 1890, his scholarly demeanor overlaid a reform-minded determination that continued when Wilson became governor of New Jersey and later president of the United States. (Historical Society of Princeton.)

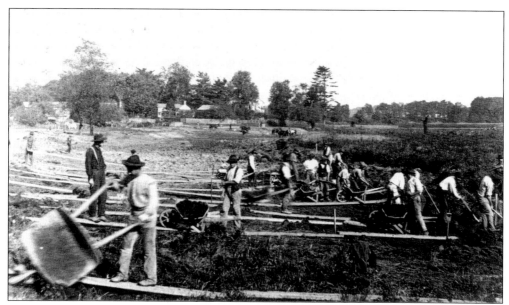

Workmen hand-dig Carnegie Lake in 1906. Instead of funding Wilson's plans for a law school, industrialist-philanthropist Andrew Carnegie gave the university money to purchase land along the Millstone River and dam the river's flow. Far from being a mere gift to the crew team, Carnegie's generosity forever provided open recreational space for the town and university. (Princeton University Library.)

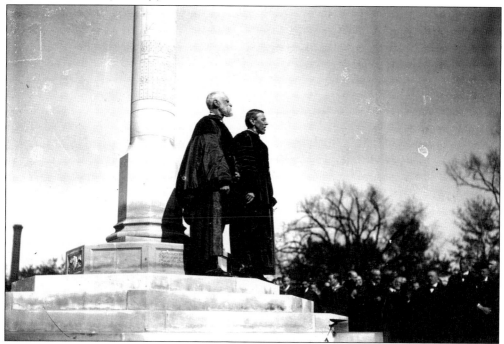

British ambassador James Bryce (left) joins Wilson in 1907 to dedicate the Mather Sundial, a replica of a 16th-century original at Corpus Christi College in Oxford University. Wilson urged the establishment of an English-style residential college system within the university, an idea fully implemented at Princeton some 70 years later. (Historical Society of Princeton.)

The newly constructed Holder Hall tower (center) looms over University Hotel *c.* 1910. Margaret Olivia Sage gave a then-immense sum of $463,000 to build the complex. The hotel, built in 1876, was a private business before it fell on hard times and was acquired by the university to serve as a dorm and a freshman dining hall. It was replaced in 1916 by Madison Hall, today part of the Rockefeller-Mathey residential college complex. (Historical Society of Princeton.)

Three

A UNIVERSITY IN THE WORLD'S SERVICE
1911–1949

I want to go to Princeton.

—Amory Blaine, the protagonist of *This Side of Paradise*,
by F. Scott Fitzgerald, class of 1917.

If the War for Independence and the Civil War bracket Princeton University's first 100 years, the institution passed through two terrible gates during its second century: World Wars I and II.

But there was a grand era between the conflicts. The vibrant American college scene helped define the Roaring Twenties: the music, fads, fashions, dance weekends, football games, parties, and the sophistication of the college man (or appearance thereof) gave energy to the "Jazz Age" (as Fitzgerald called this period).

The catastrophic stock market crash of 1929 and the subsequent Depression drained the nation of this energy, and drained its finances as well. Princeton was fortunate: many major building projects had been completed before 1930. One of most influential figures at Princeton of this period—perhaps of all time—was Ralph Adams Cram, who served from 1907 to 1929 as the university's first official consulting architect. Best known for his design of the graduate college, Cram coalesced the first real master plan for long-term development of the campus. His vision formed the university's vistas.

During World War II, Princeton was again a training hall for the forces of democracy. This time, its Gothic battlements were also a refuge.

Albert Einstein was only one of the intellectual émigrés who found a haven from Nazism in Princeton and made the town a world center for physics and mathematics. Einstein's appointment was at the nearby Institute for Advanced Study, but he maintained close contacts with brilliant university colleagues and former Europeans, notably John von Neumann and Eugene P. Wigner.

Another heritage of the war was the advancement of women in American academia. Facing a shortage of male instructors for basic courses, Princeton and other colleges were quick to call upon the many wives of professors and lecturers who held doctoral degrees and were accomplished scholars in their own right. "Rosie the Riveter" had her "Lucy the Lecturer" equivalent.

The final Allied victory in 1945 closely preceded the bicentennial of Princeton University in 1946. No wonder the 200th-anniversary celebrations were so grand, bursting with optimism for the future's possibilities.

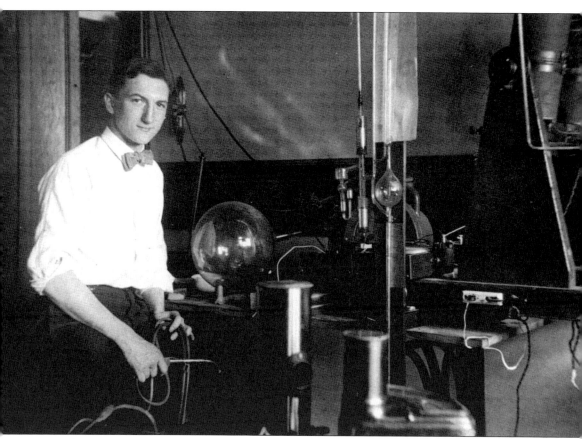

Scientific curiosity sparks in this student's eyes during an electrical engineering experiment in Palmer Physical Laboratory. Princeton was entering the 20th century with all its promise and challenges. (Princeton University Library.)

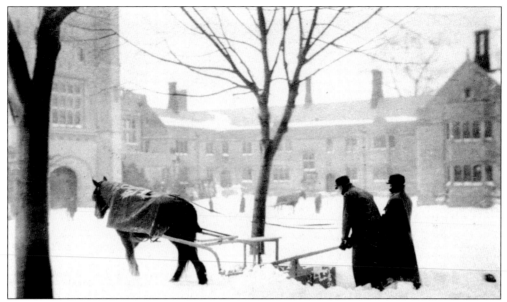

Horse power of the literal kind drives this snowplow near Blair Hall *c.* 1910. (Princeton University Library.)

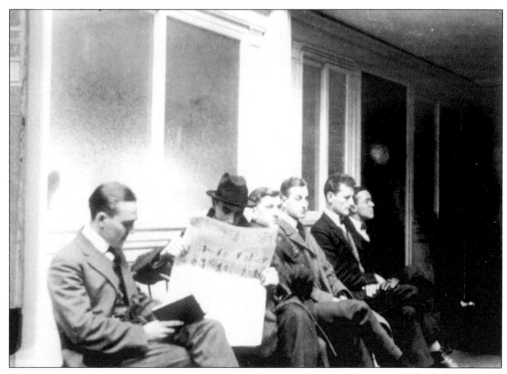

Waiting to see the dean has never been easy, as these students on Mourner's Row in 1914 could attest. The two who are reading seem at ease, while the others, perhaps, are still mentally rehearsing their stories. (Princeton University Library.)

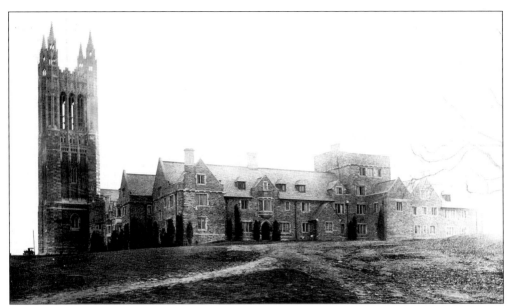

The newly built Princeton University Graduate College rises in majestic Collegiate Gothic style. The college was originally intended for a location within the main campus, but Andrew Fleming West, the first dean, successfully found funding for a larger, more removed complex. Its enduring beauty is a tribute to university consulting architect Ralph Adams Cram, as is its subsequent enhancement by longtime campus landscape architect Beatrix Farrand. (Historical Society of Princeton.)

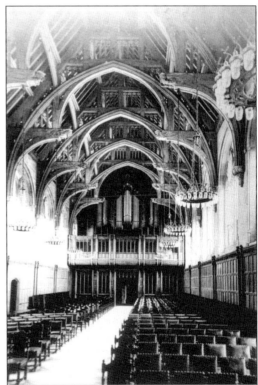

The overarching ceiling of Great Hall was intended to inspire a soaring commitment to Western moral and intellectual values. (Princeton University Library.)

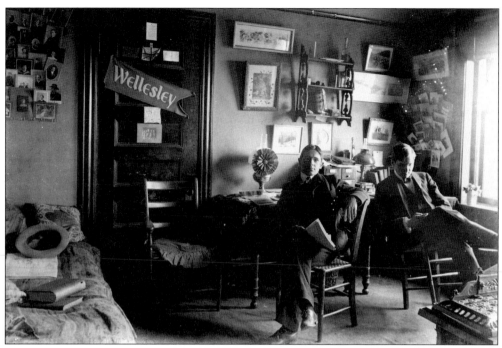

Undergraduates in this undated photograph display a Wellesley pennant in their room, indicating that women's colleges and their student bodies were kept in mind. (Historical Society of Princeton.)

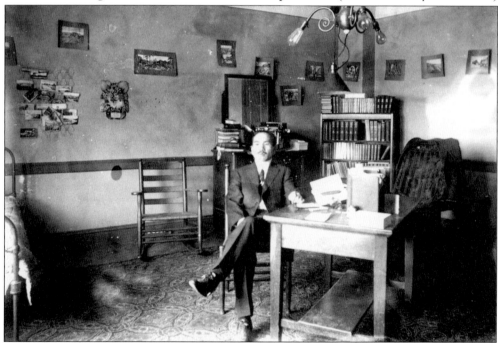

Hikoichi Orita, class of 1876, who returned to his native Japan to become an influential educator, is believed to be the first Asian graduate of Princeton. This unidentified student in Brown Hall, *c.* 1913, may be Hsu Ku Kwong, class of 1914, the university's first student from China, who later became a successful businessman and diplomat. (Historical Society of Princeton.)

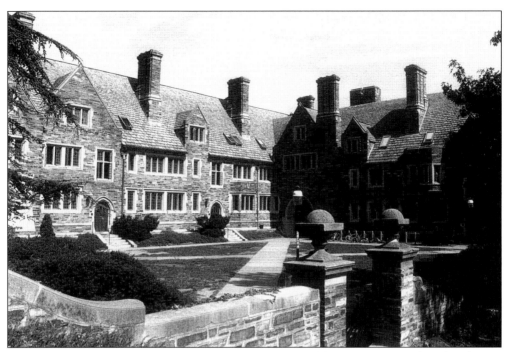

Cuyler Hall, built in 1912, has been praised by architectural historian Raymond P. Rhinehart as "the most handsome of Princeton's residential halls" and "Collegiate Gothic at its most inventive." (Richard D. Smith.)

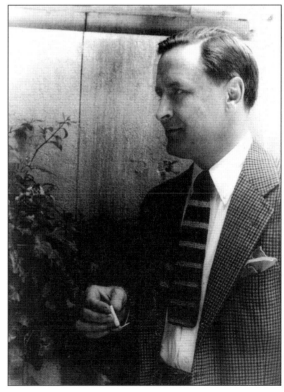

F. Scott Fitzgerald (1896–1940) never graduated with his class of 1917 because he withdrew to enlist for World War I service. Yet Fitzgerald's masterly and finely observed 1920 autobiographical novel, *This Side of Paradise*, has made the author's undergraduate years the quintessential Princeton experience. (Library of Congress.)

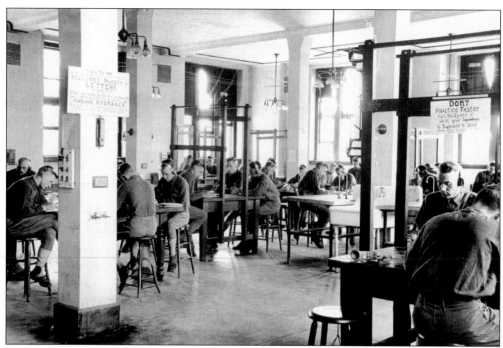

During World War I, the Palmer Laboratory was converted to use for radio-telegraphy classes and communications training. Signs posted here urge students to concentrate on accuracy of transmission, not speed. (Princeton University Library.)

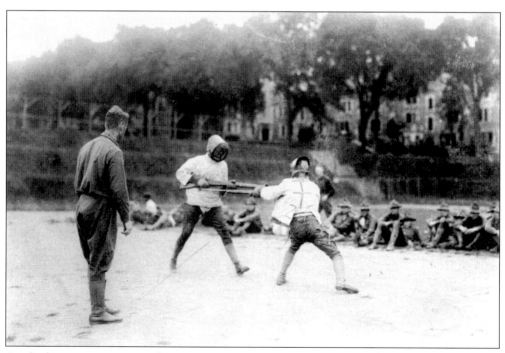

On the lower campus in 1916, bayonet practice prepares student-soldiers for the grim realities of trench warfare. (Princeton University Library.)

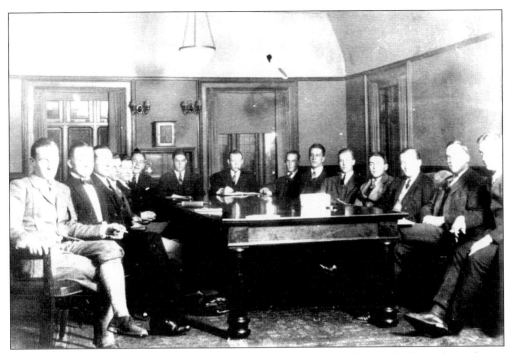

The university's senior council gathers for deliberations in 1922. The nattily dressed member at the far left is Adlai Stevenson, future senator, presidential candidate, and United Nations delegate. (Princeton University Library.)

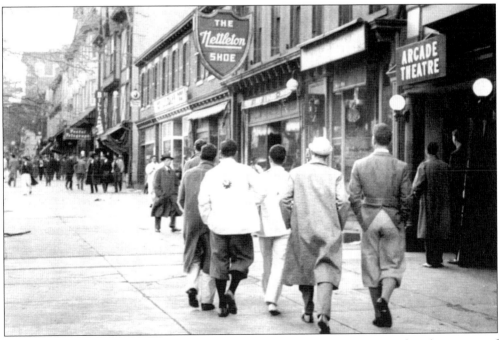

If the 1920s did not roar in Princeton, they certainly purred. Here a group of students—two of them in classic undergrad beer jackets—stroll down Nassau Street. (Princeton University Library.)

An antebellum Southern mansion? No, this is the Princeton Inn, a popular private hotel built in 1925. It was acquired in 1970 to become a dormitory, confusing nearly a decade's worth of returning customers. In 1984 the building was named by publisher Malcolm S. Forbes, class of 1941, in honor of his son Steve (Malcolm S. Forbes Jr., class of 1970). (Princeton University Library.)

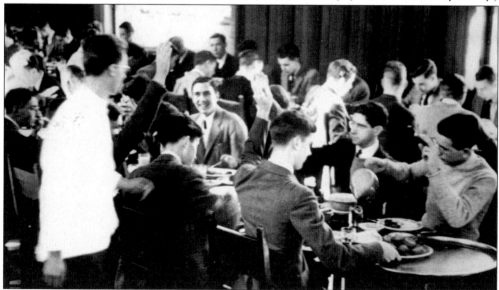

Today's students enjoy high-quality but informal cafeteria-style meals. However, dining at Princeton was once a waitered, tie-and-jacketed affair, as witnessed in this 1937 view of a meal in the Madison Hall commons. (Princeton University Library.)

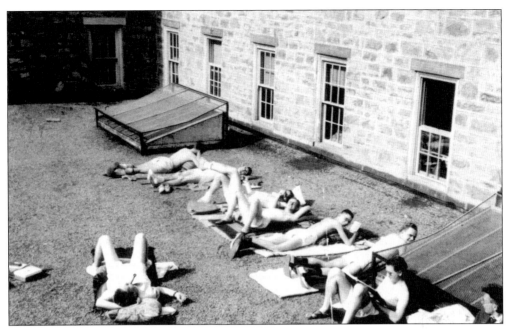

Attending school miles away from any beaches, Princeton students have learned to improvise when it comes to sunbathing. This 1937 group reclines (with classwork, of course) behind West College. (Princeton University Library.)

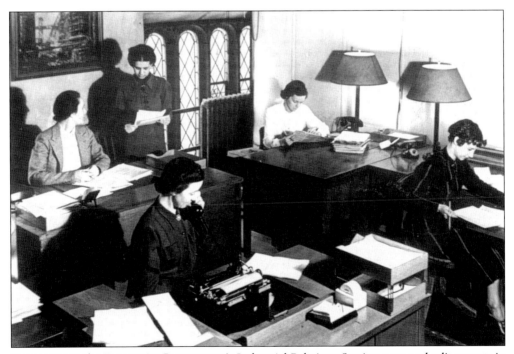

Secretaries in the Economics Department's Industrial Relations Section type and edit reports in 1938. World War II soon created opportunities for women to emerge as instructors and eventually professors. (Princeton University Library.)

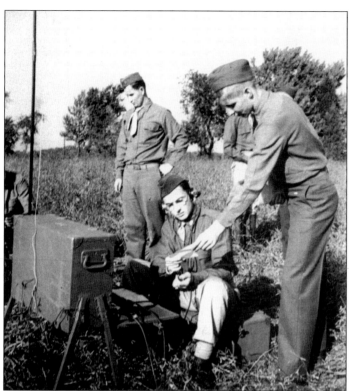

Princeton University contributed mightily to efforts during World War II, with as many as 20,000 servicemen receiving training on the university grounds, such as the field communications practice seen here. (Princeton University Library.)

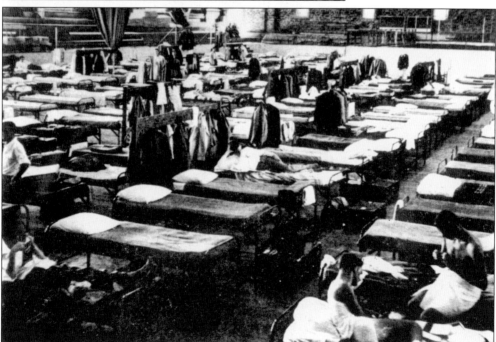

Princeton continued to house soldiers for a brief period following the war. Here, in 1946, cots stretch wall to wall at the university hockey rink, nicknamed "Baker Hotel." (Princeton University Library.)

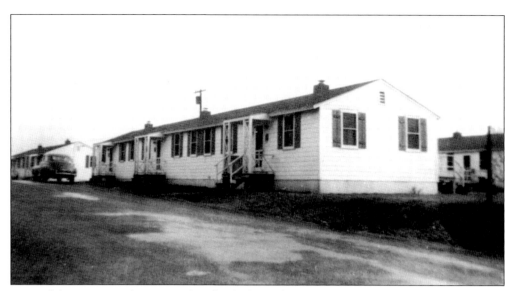

Many of the veterans who returned to finish their education at Princeton were accompanied by their brides. To accommodate the couples, the university hurriedly erected housing in 1946 on its Butler Tract on Harrison Street. The barracks-like structures were supposed to be temporary. However, six decades later, they are tolerated and even loved by the graduate students assigned to them. (Princeton University Library.)

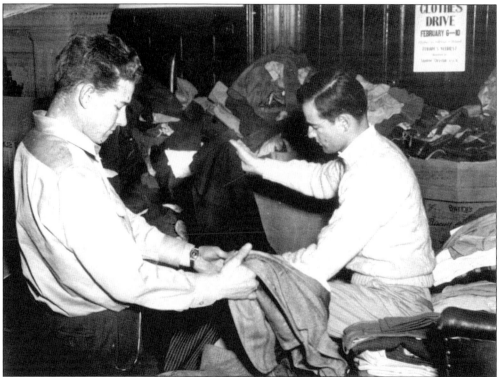

During the Cold War, Princeton students found ways to reach out to colleagues behind the iron curtain. This 1947 drive collected warm clothing for students at the University of Warsaw. (Princeton University Library.)

Honored guests at the university's triumphant 200th anniversary included U.S. chief executive Harry S. Truman (far left) and former president Herbert Hoover (second from right). (Princeton University Library.)

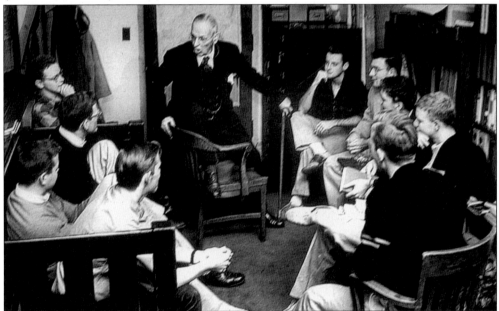

Walter Phelps Hall was among Princeton's most popular—and most memorable—professors. He was seldom without a pipe and walking stick. Hall sometimes stood on his desk while teaching. His noisy hearing aid earned him the affectionate sobriquet "Buzzer." But his history classes imparted solid learning. Seen here with a small precept, Professor Hall was used to larger audiences: In 1952, his last course lecture drew 700 attendees and had to be held in Alexander Hall. (Princeton University Library.)

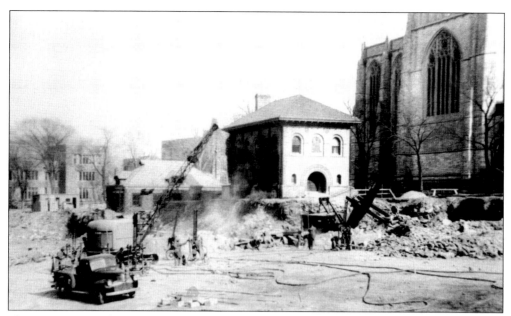

The construction of Firestone Library begins in 1946. To make room for this monumental and bold new repository, the little 1877 Biology Laboratory was sacrificed. However, the name stone that hung above its door was built into the library's exterior wall to mark the laboratory's former location. (Princeton University Library.)

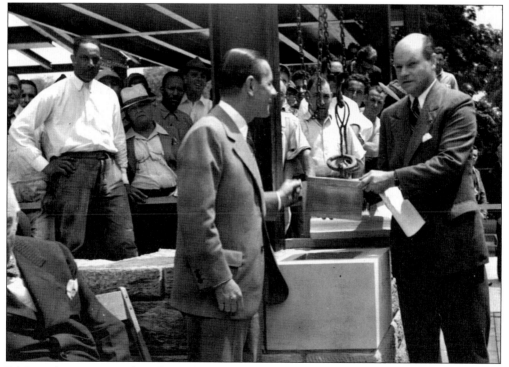

While a diverse crew of workmen look on with curiosity and pride, the cornerstone of the new Firestone Library is sealed at the 1947 dedication ceremony led by university president Harold Dodds (right). (Historical Society of Princeton.)

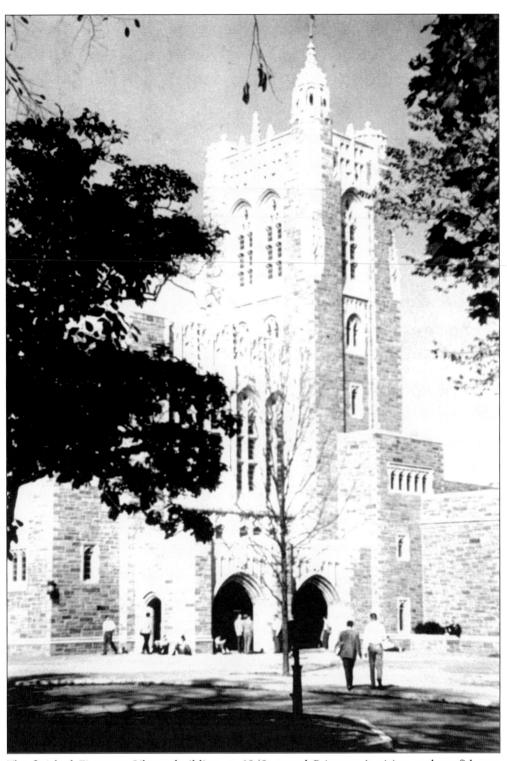

The finished Firestone Library building, *c.* 1949, stated Princeton's vision and confidence. More than half a century later, it still does. (Princeton University Library.)

Four

THE ARTS

THE LIFE OF THE SOUL

It is the Great Vitrine for youth . . . the proving ground for talent that still is permitted to fumble; it is a place to sing, to do pratfalls, to thumb one's nose at authority, to test the last liberties of adolescence, to taste the true wine of being an American.

—Joshua Logan, 1931, writing about Triangle Club in the foreword to *The Long Kickline,* by Donald Marsden, 1964.

The arts at Princeton did not have an auspicious beginning.

When John Witherspoon arrived in America, he was already an opponent of the theater. In 1757, he had written a tract entitled *A Serious Inquiry into the Nature and Effects of the Stage: Being an attempt to show that contributing to the support of the public theatre is inconsistent with the character of a Christian*. It is no wonder that for decades the classic Greek, Hebrew, and Latin texts—and not Shakespeare—were studied at the College of New Jersey.

Music was part of early chapel services but apparently was wanting in quality. "The Schollars [at Princeton] sing as badly as the Presbyterians at New York," sniffed future U.S. President John Adams after a 1774 visit.

But artistically inclined students banded together for fun and merriment, benefiting and even changing the school at large. Consider the Princeton College Dramatic Association, which was founded in 1883 and 10 years later became the Triangle Club. The organization was not just responsible for witty original musicals; it also gave rise to the school's first true campus center (the Casino) and Princeton's prize-winning regional theater (McCarter Theatre.)

The first-known student bands in the early 1800s eventually provided the chords and scales for the founding of the Department of Music as a formal and highly respected academic entity.

If much music has been made at Princeton, much music has also been made about it. At the top of the repertoire is the school's sentimental but stirring alma mater, "Old Nassau" (written in 1859 by Harlan P. Peck, class of 1862, and set to music by Prof. Karl Langlotz). Other delightful examples abound: "Orange and Black March," by Harold Nason, class of 1898; "The Princeton Cannon Song," by Arthur H. Osborn, class of 1907; and "Forward March Princeton" and "The Battle Song of Princeton," by Kenneth S. Clark, class of 1907. (Clark also composed "When You Steal a Kiss or Two," showing that his interests were not limited to martial displays of college loyalty.)

Princeton was a pioneer in the study of the classical arts. The 1831 college catalog lists lectures on Roman antiquities, evidence that Princeton was the first American college to offer art and archeology as a formal combined study. Today, the Princeton Art Museum has one of the finest and best-balanced collections for any art museum of its size. The university's programs in creative writing, theater, dance, and other artistic endeavors are popular and widely respected.

Boosting the arts at Princeton is the university's astonishing talent pool, in which talented performers—from decorous dancers and vibrant violinists to jaunty jugglers—find their peers.

But many students arrive on campus with little prior creative training or experience. Then one day—often on impulse—they attend a performance, sign up for a class, or join a club. Something stirs deep within. Those who do participate are rewarded by discovering their own real talents for music, dance, painting, photography, or writing.

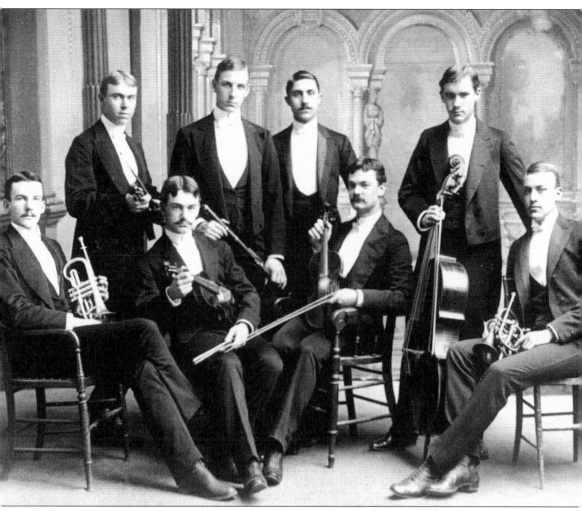

The nattily attired college band sits for a studio portrait in 1886. The arts at Princeton have consistently risen from part-time student pastimes to formally studied pursuits. (Princeton University Library.)

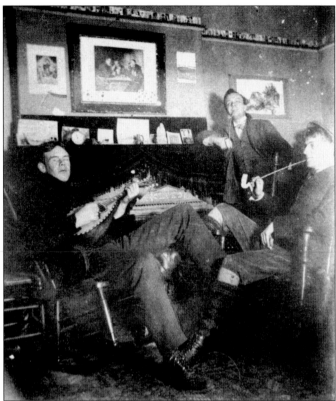

A mandolin player entertains pipe-savoring roommates in Brown Hall in 1898. The instrument was once so popular that models were produced bearing college names, including Princeton's. (Princeton University Library.)

The Casino was arguably the university's first theater and campus center. Here, the Princeton College Dramatic Association, the Casino's builder, rehearses an elaborate song-and-dance routine c. 1920. (Princeton University Library.)

The 19th-century practice of step singing at Nassau Hall on spring evenings was an overture to the creation of 20th-century vocal groups that, likewise, have made various campus arches ring with song. (Princeton University Library.)

In 1893, the Princeton College Dramatic Association changed its name to Triangle Club. In 1930 the Triangle Club presented its first show in its new McCarter Theatre, a production of *The Golden Dog*. The show featured future Broadway and film director Joshua Logan, class of 1931 (left), and A. Munroe Wade, class of 1930, who later became a beloved Princeton secondary-school drama coach. (Princeton University Library.)

The 1932 production of *Nerissa* by Theatre Intime (the intimate theater group in Murray-Dodge Hall) featured Jimmy Stewart, class of 1932 (seated right), who soon became one of America's most popular movie stars. During World War II, Stewart was a courageous bomber pilot who flew multiple missions over Europe. (Theatre Intime.)

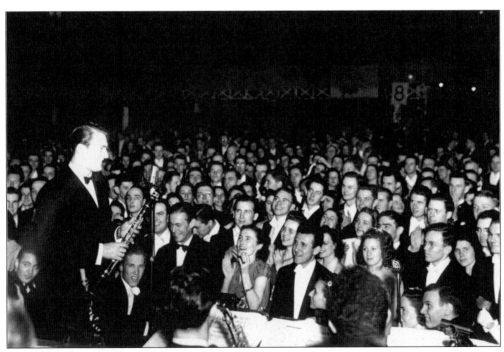

Students at a late-1930s junior ball are thrilled by famed clarinetist Artie Shaw and his big band. Over the years, a pantheon of popular music stars has entertained at Princeton. (Princeton University Library.)

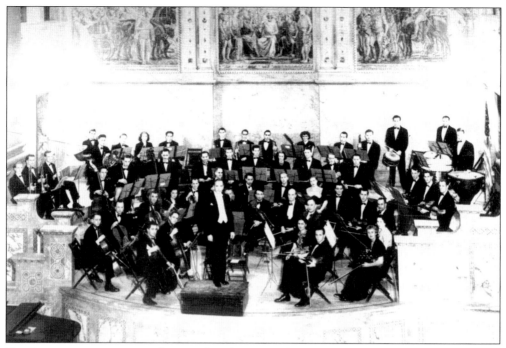

The Princeton University Orchestra takes the stage of Alexander Hall in 1949. The renovated concert space, now known as Richardson Auditorium, is considered one of the most acoustically pleasing in the country. (Princeton University Library.)

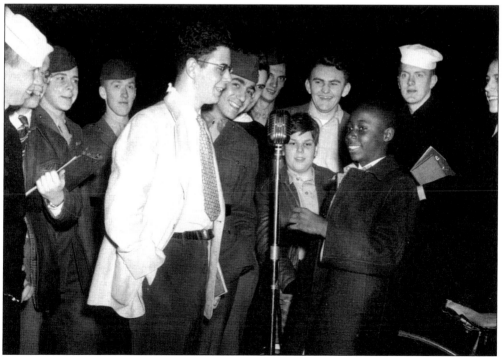

Frederick Rhinestein, class of 1949, did popular "Roaming with Rhinestein" remote interviews on WPRU radio, the forerunner of today's eclectic station WPRB. (Princeton University Library.)

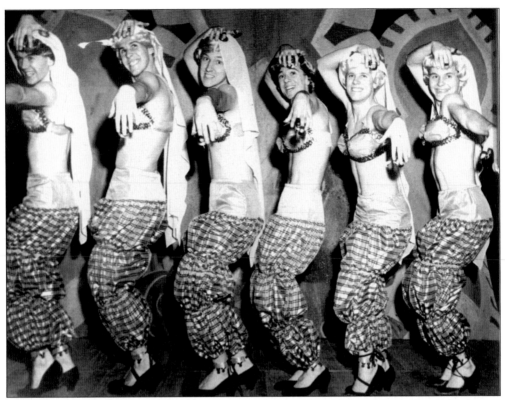

The Triangle Club's traditional all-male kick line featured a harem of somewhat hirsute belly dancers in its 1954 production of *Tunis, Anyone?* (Princeton University Library.)

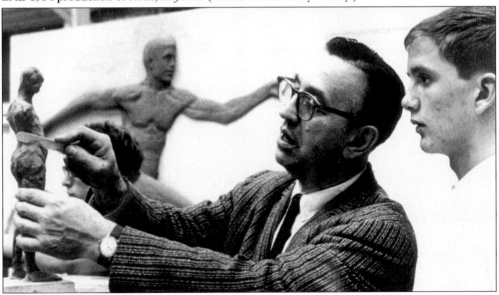

Born a poor boy in a tough South Philadelphia neighborhood, Joe Brown (center) attended the University of Pennsylvania on athletic scholarships. A stint as a figure model inspired Brown to take up art, at which he excelled. For years, this remarkable personality was both Princeton's sculpture teacher and its boxing coach. (Princeton University Library.)

The Nassoons, founded at the university in 1941, were followed by other lively and accomplished a capella vocal groups, including the Tigertones (shown here in the 1970s) and—after coeducation—the Tigerlilies. All are inheritors of the venerable Princeton step-singing tradition. (The Tigertones.)

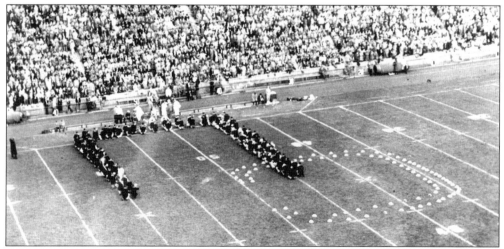

In a linearly disciplined departure from their usual madcap choreography—and with the help of their trademark straw hats—the Princeton University Marching Band spells out a "C. U." tribute to Cornell University during a halftime performance at a 1950 football game. (Princeton University Library.)

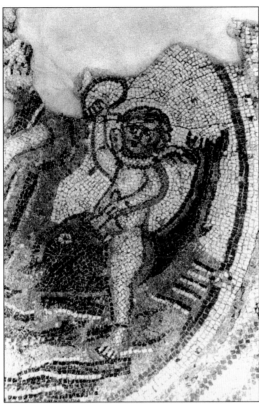

Foreign expeditions by members of the Department of Art and Archeology in the 1920s succeeded in uncovering and preserving significant Roman mosaics. This boy on a dolphin, found in Antioch, now cavorts on an exterior wall of the art museum. (Richard D. Smith.)

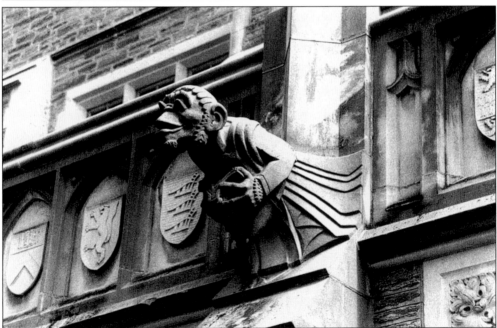

Pictures of the imaginative gargoyle-style carvings on campus buildings could fill many books, and they have. This bespectacled monkey scholar smiles beneficently upon Dillon Gym users. (Richard D. Smith.)

Face of a Woman, by Pablo Picasso, stood for many years in front of the Princeton University Art Museum. The sculpture was relocated in June 2002 during the expansion of the Marquand Library of Art and Archeology, and now gazes before the cubistic Spelman Hall. (Richard D. Smith.)

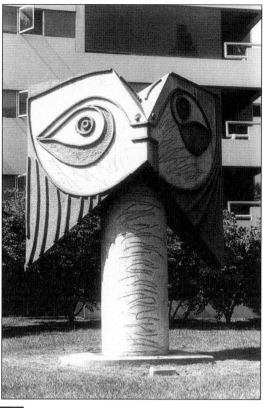

Another highlight from the 20-piece, campuswide Putnam collection of sculpture (funded in memory of Lt. John B. Putnam Jr., class of 1945) is this work by Henry Moore, called *Oval with Points.* Suggesting reconnection within a whole, the sculpture was set on the former site of Reunion Hall. (Constance Carter.)

Major multitasking? Juggling the demands of university life? College life is easy for these students outside Alexander Hall on a sunny Saturday in 1993. (Princeton University Library.)

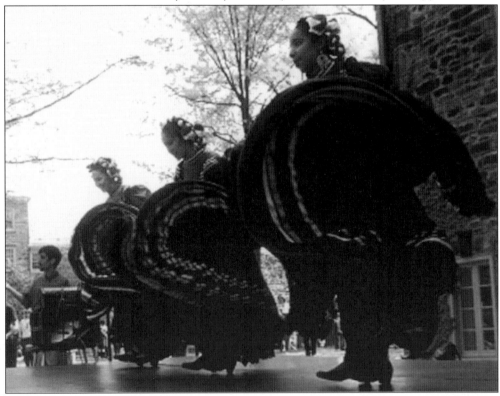

For more than two decades, the annual Communiversity fair has united town and campus for a festive April day of music, arts, crafts, and exhibitions. Seen here, the Ballet Folklorico de Princeton performs traditional Mexican dances in front of Nassau Hall. (Ballet Folklorico de Princeton.)

Many student events have an artistic flair and flavor. Members of the Chinese Student Association are joined here by cultural center director Paula Chow (far left) during a Shanghai nightclub–theme party. (Chinese Student Association.)

Mixing humor and poignancy, the plays of the Princeton South Asia Theatrics (P-SAT) often examine the competing demands of traditional and modern cultures. In this view, Ishna Berry, class of 2008; Nitin Walia, class of 2006; and Dave Uppal, class of 2008, rehearse for P-SAT's 2004 production *Salaam Kishore*. (Sayuri Jinadasa, class of 2008.)

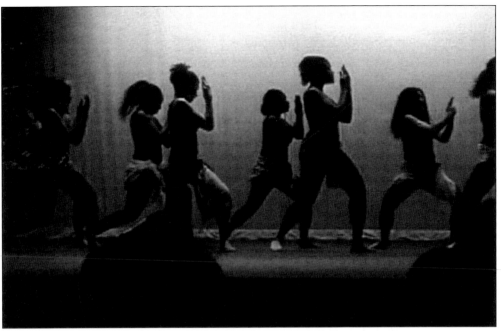

The Black Arts Company has dance and drama troupes, both accomplished. Its dancers form one of several high-energy student ensembles enjoyed at Princeton. (Black Arts Council.)

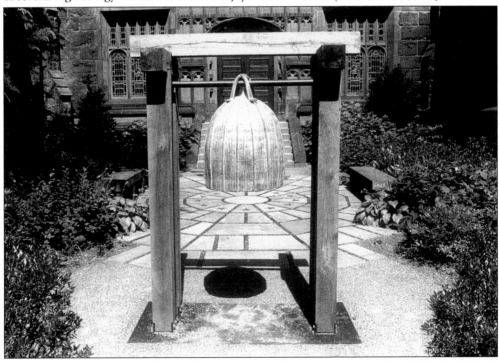

Princeton lost 13 alumni during the terrorist attacks on September 11, 2001. Acclaimed sculptor-ceramist Toshiko Takaezu, a former Princeton art instructor, cast this remembrance bell for the university's September 11 Memorial Garden, a sonorous affirmation of life. (Richard D. Smith.)

Five

RELIGION

THE LIFE OF THE SPIRIT

*And not excluding any Person of any religious Denomination whatsoever
from . . . any of the Liberties, Privileges, or immunities of the . . . College,
on account of his . . . being of a Religious profession Different from the . . .
Trustees of the College.*

—Original charter of the College of New Jersey,
October 22, 1746.

The Great Awakening was a powerful religious revival that began in England and spread through
the American Colonies in the first half of the 18th century. Rev. Jonathan Edwards, the college's
third president, was among its prime leaders. In America, the "New Light" wing of the Awakening
stressed a direct personal relationship with God. They believed that God holds each person
accountable for the well-being of their community and their country.

It is no wonder that in 1760, in the earliest-recorded Princeton baccalaureate address, college
president Samuel Davies's topic was "Religion and Public Spirit." Davies exhorted the students:
"Live not for yourself but the Publick. . . . Esteem yourselves so much the more happy,
honourable and important by how much the more useful you are. Let your own Ease, your own
Pleasure, your own private Interests, yield to the common Good." Surely we find the antecedents
of Woodrow Wilson's famous sesquicentennial speech, "Princeton in the Nation's Service," in the
beliefs of the Great Awakening.

If the founders' original goal had been to create New Light ministers, they quickly took up the
greater mission of liberal education. One of the founders wrote: "Though our great Intention

was to erect a seminary for educating Ministers of the Gospel . . . we hope it will be useful in other learned professions. . . . Therefore we propose to make the plan of Education as extensive as our Circumstances will admit."

Although not officially a religious institution, the early college was not lax about spirituality. Before the construction of a freestanding chapel in 1847, daily services were held in Nassau Hall. Religious observance and scholarship were equally austere. Philip Vickers Fithian, class of 1772, recorded in his journal, "After Morning Prayers [at 5:30 a.m.], we can, now in the winter, study an hour by candle Light every Morning."

The neighboring but separate Princeton Theological Seminary was established in 1812 as the first Presbyterian seminary in America. Like the university, it too became a place of broad ecumenical teaching.

Today, a rainbow of religious faiths and spiritual practices are observed at Princeton. The chapel takes deserved pride in opening its doors to all faiths who ask to use it. Although regularly scheduled services are rooted in the Protestant tradition, there is also a Catholic chapel within its walls.

The Muslim Student Association (MSA) has presented evenings of Koran recitations and Sufi music in the chapel with great success. (Respecting Islam's discouragement of personal religious images, no pictures of Muslim activities are presented here. But the MSA's important contribution to campus life is certainly noted.)

The Center for Jewish Life contains an active synagogue and organizes many well-received public events. A Buddhist group conducts ongoing Zen meditation sessions. The university's Council of Religious Life has included, among others, Hinduism, Janism, Native American traditions, and the Church of Jesus Christ of Latter-day Saints.

In truth, Princeton's historical record of religious diversity has not been unblemished. For years, admission decisions kept the student body far too homogeneous—ethnically, socially, and also in religion. But the university progressed, becoming diverse and fulfilling the tolerant goals of its founders. It is no wonder that today Princeton is blessed with an international community of students and scholars.

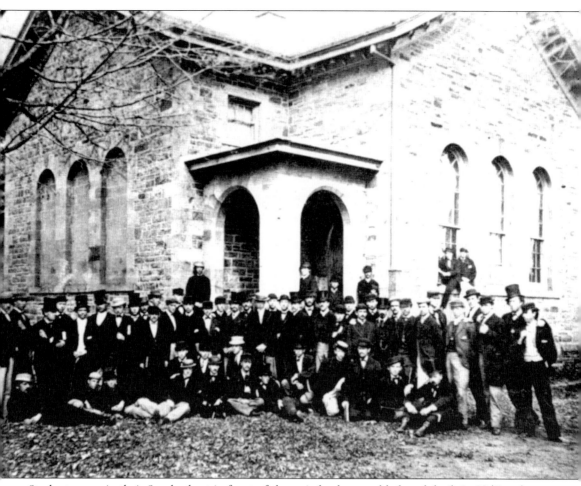

Students pose in their Sunday best in front of the quietly elegant old chapel, built in 1847 and called "a beautiful smile on a plain face" (in comparison to other campus architecture). Much loved and much used during its lifetime, it was superseded in 1882 by the larger Marquand Chapel, and then razed in 1896 to make way for East Pyne. (Princeton University Library.)

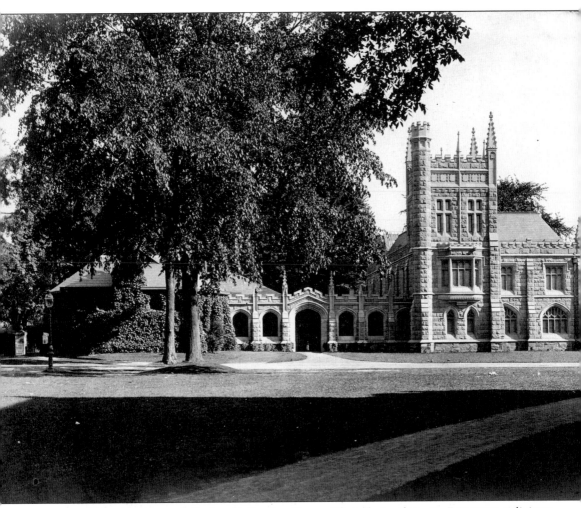

Churchlike Murray and Dodge Halls visually manifest their place in Princeton religious history. Murray was built in 1879 with offices and a chapel for Revivalist groups. Dodge Hall was added in 1900 and named for Earl Dodge, class of 1879, president of the Philadelphian Society (an influential campus religious organization that previously had occupied Stanhope Hall). The statue of the athletic *Christian Student,* by Daniel Chester French, was placed opposite Murray-Dodge Hall to commemorate the founding there of the International Young Men's Christian Association. Today, while the former chapel in Murray is now a theater, Dodge Hall is home to an ecumenical mix of religious groups and spiritual activities. (Historical Society of Princeton.)

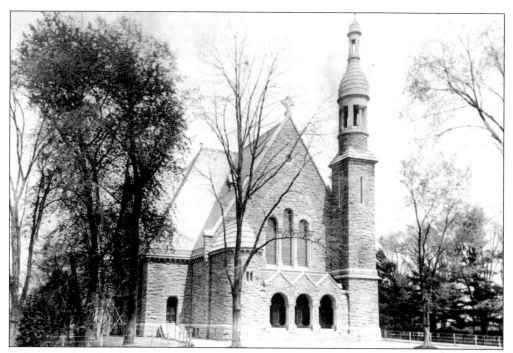

Little remembered today, Marquand Chapel was a spectacular structure. It was a gift in 1882 from Henry Marquand—wealthy New York banker and father of a Princeton student—who also endowed the Metropolitan Museum of Art. Unlike the later Gothic-style University Chapel, the Marquand had Byzantine and Romanesque elements. Standing in what is now the McCosh courtyard, the Marquand's inspirational tower was visible for miles around. (Princeton University Library.)

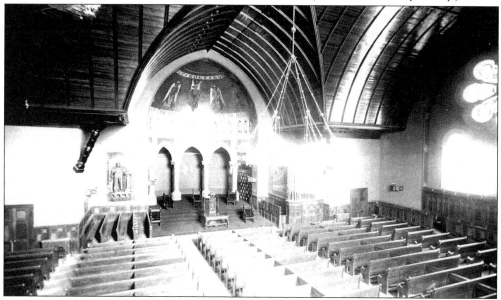

The Marquand's magnificent interior is shown here. Many of its stained-glass windows were crafted by the famous studio of L. C. Tiffany. Tragically, the chapel burned in the same 1920 fire that consumed neighboring Dickinson Hall. For the next eight years, services were held in Alexander Hall. (Princeton University Library.)

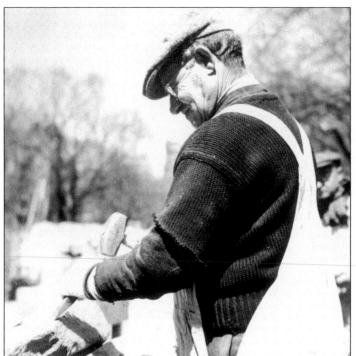

As a monumental new chapel is constructed in 1924 to replace the Marquand, a stone cutter practices his craft with pride and strength. Many Italian-American families in the town of Princeton trace their heritage to stonemasons who came to America to work on university building projects. (Princeton University Library.)

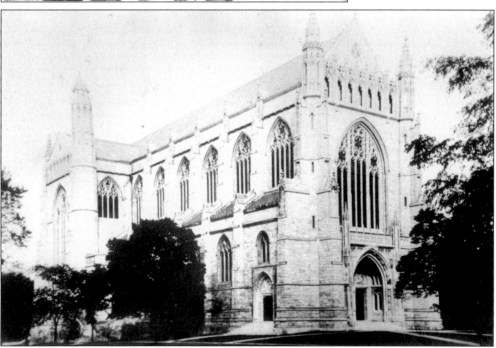

A visiting alumnus sent this postcard of the new chapel to a minister friend on August 11, 1928, writing, "You will be interested in this wonderful building, just completed." And a wonder it was: 270 feet long inside, 58 feet wide, and 76 feet high, its choir's wood from Sherwood Forest, the pews made from wood once stockpiled for Civil War cannon carriages. (Princeton University Library.)

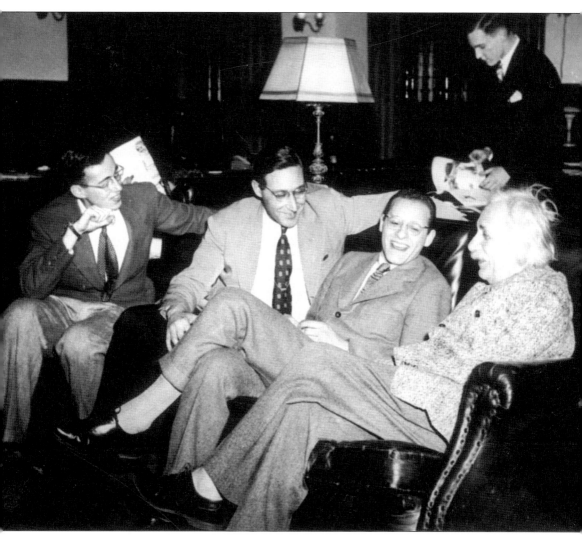

Albert Einstein (1879–1955) arrived in Princeton in 1933 to join the newly formed Institute for Advanced Study. He was never on the university faculty, but he occasionally gave lectures here and occupied a Mathematics Department office in the original Fine Hall while the institute was being built. Although not formally observant, his work in theoretical physics resonated with a sense of the mystery of God's universe. He was an early supporter of Israel and was actively involved in the local United Jewish Appeal. A modest genius with a common touch, Einstein is seen here enjoying a visit with student members of the Hebrew Association. (Princeton University Library.)

On January 27, 1987, Hugh Wynne, class of 1939, had reason to smile, as he had just succeeded in bringing back the *Christian Student* from the Daniel Chester French Museum in Stockbridge, Massachusetts. This epitome of the scholar-athlete, which had once faced Murray-Dodge Hall on the Princeton campus, would now stand tall in the lobby of Jadwin Gymnasium. Sculptor French is best known for his powerful Lincoln Memorial statue. (Princeton University Library.)

Members of the Church of Jesus Christ of Latter-day Saints (often referred to as Mormons) have long observed "family home evenings" in which spiritual issues are discussed and fellowship is shared. This gathering brought together town residents and university students. (Princeton University Latter-day Saints Student Association.)

A student prepares her costume before performing a traditional dance from India. Although a cultural and not strictly religious practice, some of the dances depict stories from the sacred texts of Hinduism, and thus promote understanding of that religion's traditions. (Kalaa Classical Indian Dance Troupe.)

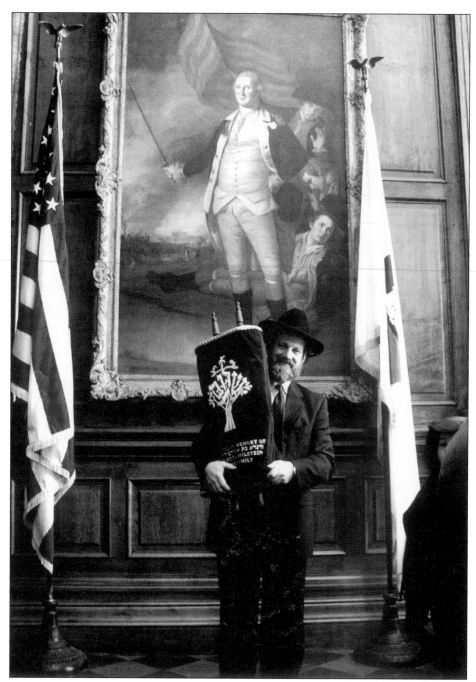

In 1999, a new Torah scroll donated in memory of the Milstein family was dedicated in Nassau Hall and then was walked to the Center for Jewish Life. Here, a schriber (the writer who completes the text during the ceremony) holds the scroll, as he is flanked by the American and university flags. Above him—depicted with sword drawn in defense of liberty—is George Washington, the first president of the United States and a friend to Princeton, who once wrote to the Hebrew congregation of Newport, Rhode Island, that "the United States . . . gives to bigotry no sanction, to persecution no assistance." (Iris Brooks Lewin.)

Six

ATHLETICS

FROM THE TIGER'S DEN
TO THE WORLD'S FIELD

It's like going to the dentist: It's painful, but it does you a lot of good.

—A rival basketball coach on playing Pete Carril's Princeton teams,
the national leaders in defense in the 1970s.

Princeton has garnered lasting laurels as a sports pioneer.

Consider this: American collegiate football began with the first Rutgers–Princeton game in 1869. Princeton versus Yale remains one of the longest football rivalries in history, contested continuously since 1873.

Baseball was played on campus as early as 1786: that year John Rhea Smith, class of 1787, recorded that he played "baste ball" (lamenting that he missed at both catching and striking the ball).

The first use of the hook slide in baseball was by Princeton student William S. Gummere, class of 1870, while stealing second in an exhibition game against the professional Philadelphia Athletics in the year of his graduation. The first successful collegiate use of the curve ball and the first no-hitter in baseball history—amateur or professional—were both achieved by Joseph McElroy Mann, class of 1876. Mann practiced during the winter in the long corridors of Nassau Hall, and then pitched his historic no-hit game on May 29, 1875, against Yale. William S. Schenck, class of 1880, created the first catcher's chest protector

when he stuffed copies of the *Daily Princetonian* under his shirt during a game against Harvard. Seeing this cleverly simple innovation, a Boston sporting goods company soon manufactured the first wearable catcher's pad.

Bicycle racing on campus began in 1879. Bert Ripley, class of 1901, developed the "scalded cat sprint" (back arched, shoulders low) for his finisher.

The angular soccer approach to football place-kicking was first employed by Princeton player Charlie Gogolak, class of 1966. His revolutionary technique soon replaced the old straight-on kicking style in both the collegiate and professional ranks.

There are few more-glorious events than the participation of Princeton students in the inaugural revival of the Olympic Games in Athens in 1896, when track-and-field captain Robert S. Garrett, class of 1897, led the United States to the unofficial team victory.

In more-recent times, Princeton basketball—as coached by Pete Carril for nearly three decades until his retirement in 1996—emphasized ball control and maximizing scoring opportunities. The Princeton style forced a renewal of finesse and teamwork in the game nationwide.

Coeducation in 1969 quickly added to the university's athletic laurels. The women's basketball team was organized in 1971 and soon began winning Ivy League championships. Women's teams in field hockey, rugby, and other sports have also been national powers.

Today there are 38 varsity sports and about 40 club teams at Princeton. But some commentators have questioned the role of athletics at Princeton and other colleges. Even though the Ivy League has no sports factories on the scale of schools with professional-style football and basketball teams, critics argue that athletes associate mostly with teammates and thus segregate themselves from the student body at large.

However, the same can be said for any student passionately committed to academic pursuits (including their own thesis research) or hobbies. The healthy and active young person is far more of an asset to the university than a detraction. Today, about half of all Princeton undergrads are on a varsity or club team. If intramural and fitness participation were included, the sports-involvement percentages would be higher still.

If anything, the student athlete typifies Princeton.

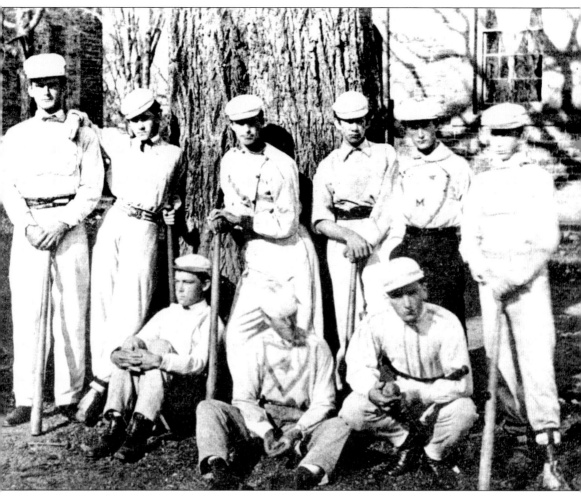

The 1870 baseball team wore snap-brimmed hats, carried serious wood, and showed no-nonsense expressions. The national game has been played at Princeton since the 1780s. (Princeton University Library.)

FOOT-BALL AT PRINCETON.

This rather fanciful engraving depicts early football at the college; the sport was then something of a cross between soccer and rugby. Princeton's rivalry with nearby Rutgers literally gave birth to the modern game. (Princeton University Library.)

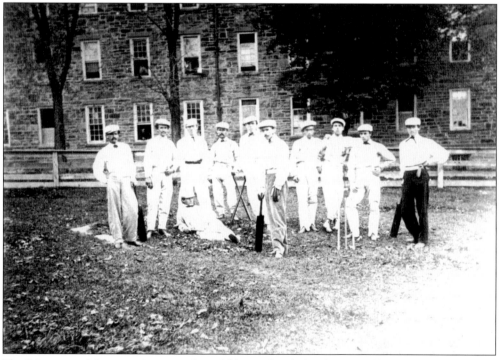

The Princeton cricket team is pictured in 1864, standing behind West College, which overlooked the early athletic fields. The university's cultural ties to its British colonial origins remained strong up through the Civil War era. (Princeton University Library.)

The Princeton crew hoists its shell into the Delaware and Raritan Canal in 1875. The canal was only suitable for practice. Andrew Carnegie's funding for the 1906 creation of nearby Carnegie Lake provided a racing venue for rowing. (Princeton University Library.)

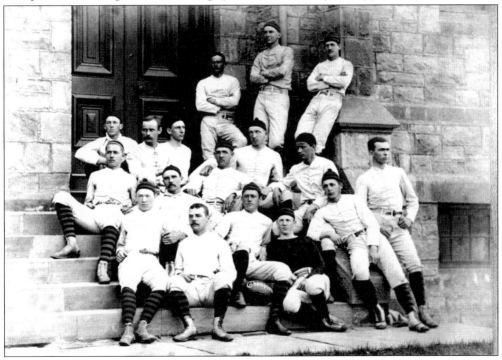

The Princeton football team relaxes in heroic fashion in the spring of 1879, having just completed a championship season. (Princeton University Library.)

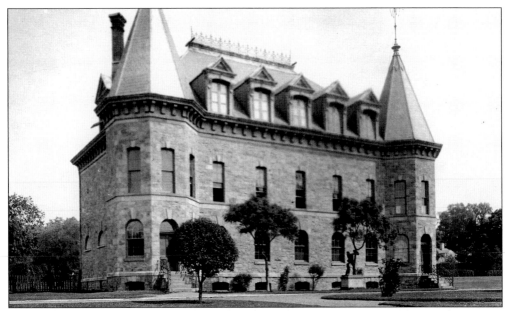

In 1870, the McCosh administration replaced a barnlike, student-run gym that had burned down with the new Bonner-Marquand Gymnasium and thus manifested the college's commitment to physical education. The gym contained a variety of exercise equipment, including gymnastics apparatuses, weights, Indian clubs, and even rowing machines. (Historical Society of Princeton.)

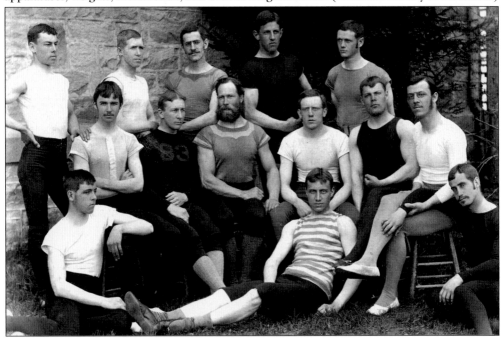

Muscular of beard as well as arm, the colorful George Goldie (seated, third from left) poses proudly in 1890 with his gymnastics students. The Scottish native was hired in 1869 as Princeton's first athletic director. Also a Highland Games champion, Goldie organized popular competitions in running, jumping, and throwing. Such events were adopted at other colleges, giving rise to modern American track and field. (Princeton University Library.)

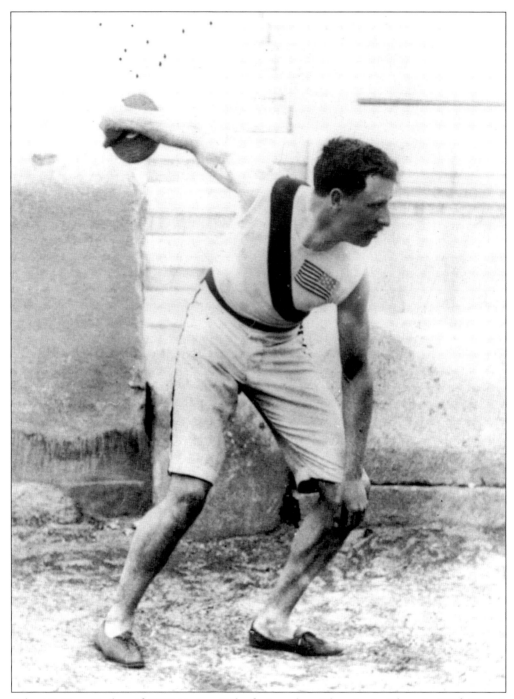

Robert S. Garrett, class of 1897, is seen at the first modern Olympics in Athens in 1896. Garrett won the shot put and was second in the long jump. He entered the discus throw out of curiosity about the ancient art. The official platter used in competition was much lighter than the bulky practice implement made for him by a Princeton blacksmith, and in the end, Garrett was the surprise winner. He went on to a successful banking career, and provided the core of Princeton's superb collection of Islamic manuscripts. (Princeton University Library.)

Among the legends of Princeton football are the six Poe brothers, "all short and stocky, strong and fast" according to one sports historian. Neilson "Net" Poe, class of 1897 (flanked here by teammates Bill Edwards, left, and Pete Balbret), was later a supportive coach of scrub players at Princeton. His crew was called "Poe's Omelettes"—good eggs who kept getting beaten up. (Princeton University Library.)

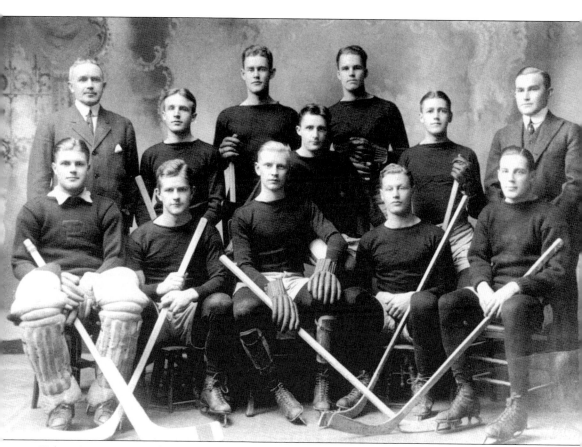

Hobart Amory Hare Baker, class of 1914 (seated second from the right), is among the greatest college athletes of all time. He was an all-American football halfback whose 92 points scored in the 1912 season stood as a Princeton record until the 1970s. He also rivaled golf and tennis professionals at their own games. But it was on the hockey ice that the Hobey Baker legend crystallized. Weaving magically through opponents, his rink-length drives brought crowds to their feet with cries of "Here he comes!" Baker served as a fighter squadron commander during World War I and died in a 1917 crash while making a test flight, his discharge orders in his pocket. Baker Rink—the first artificial ice rink on a college campus—was dedicated to him, with university president John C. Hibben extolling Hobey's "spirit of manly vigor, of honor, of fair play, and the clean game." (Princeton University Library.)

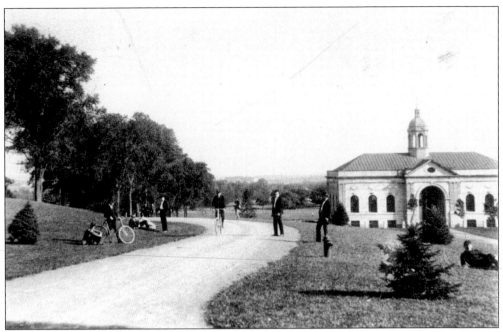

The Brokaw Memorial, built in 1892, was named for Frederick Brokaw, class of 1892, who drowned the summer after his junior year. This charming structure housed an indoor pool. The building was torn down in 1947 to make way for Dillon Gymnasium. (Princeton University Library.)

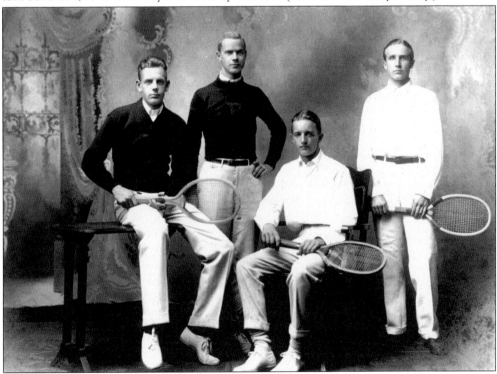

Perfect gentlemen and athletes, the tennis team sits for a quintessential turn-of-the-century studio portrait. (Princeton University Library.)

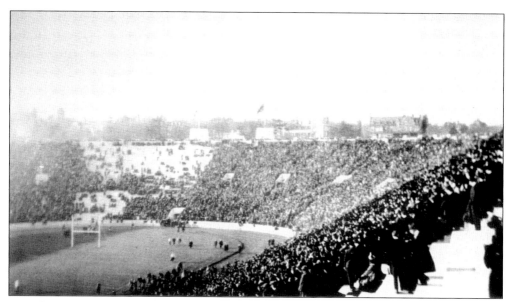

Completed in 1914, Palmer Memorial Stadium—one of the first constructed using reinforced-concrete technology—was given to the university by Edgar Palmer, class of 1903, in memory of his father, Stephen Palmer. The 45,000-seat venue drew generations of fans for gritty football games and thrilling track and field meets. Weathering of the structure forced the stadium's demolition in 1997. The new Princeton Stadium has been enthusiastically received by architectural critics. (Princeton University Library.)

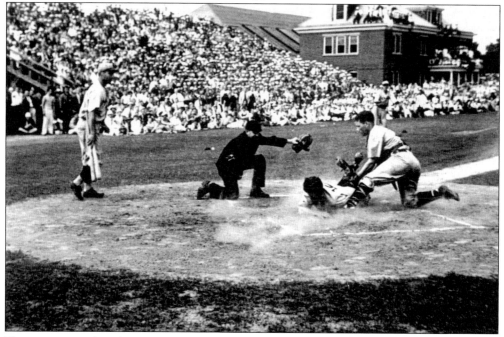

This runner is safe at home, c. 1932. For decades, sports fans jammed bleachers at the athletic fields at Prospect and Olden, and even risked sitting on rooftops to get a better view of Princeton sporting events. Now occupied by the Engineering Quadrangle, this site is still bordered by its stately brick wall. (Princeton University Library.)

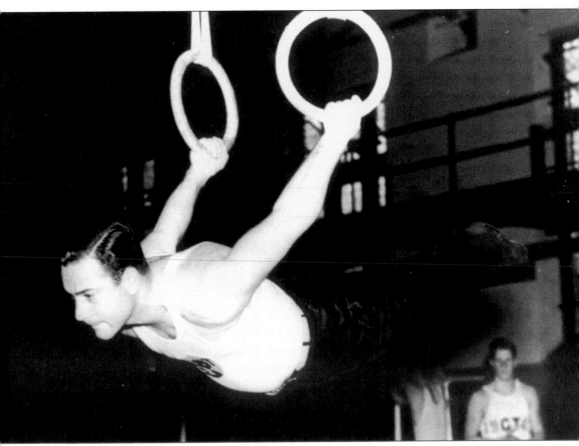

Arnold J. Trattler, class of 1940, works out on the rings in the gymnasium. (Princeton University Library.)

The university's gymnasium was being used as a barracks for soldiers when the building was gutted by a terrible fire in May 1944. The Dillon Gym was quickly built to replace it. Lost in the fire were the gym's marvelous murals, including the wrestler and lacrosse player pictured here. (All Princeton University Library.)

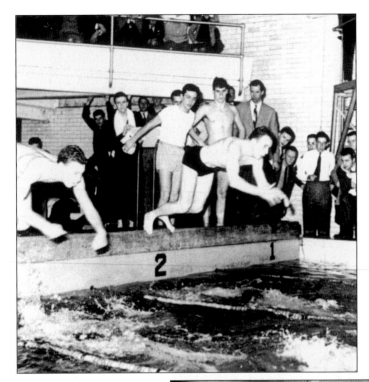

This men's swimming relay race took place in the late 1940s in the Dillon Gym pool. Today's Denunzio Pool features high-tech wave dampers to yield the fastest possible times, but the excitement of competition is unchanged. (Princeton University Library.)

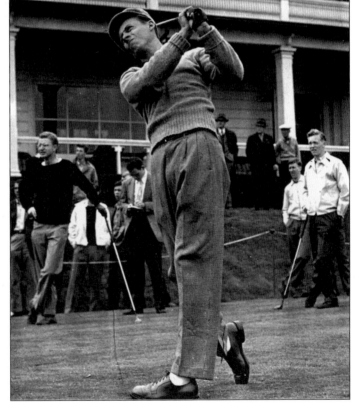

Jack Houdry, class of 1949, drives strongly as Harry Sayen, class of 1943, looks on at left. Princeton varsity golfers take the game seriously, and both the main and graduate campuses benefit from the open vistas of the neighboring Springdale Golf Course. (Princeton University Library.)

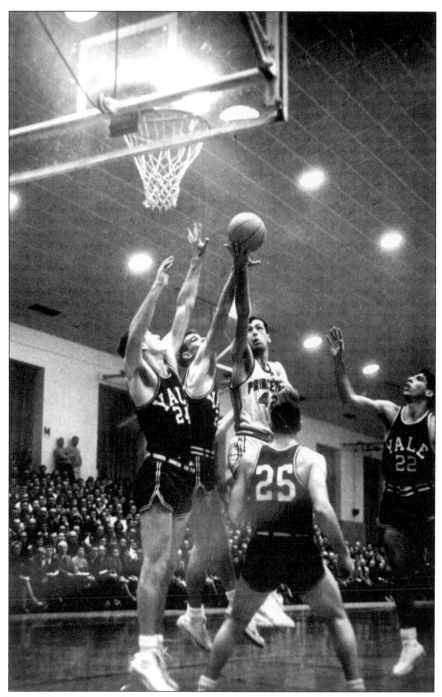

Four-fifths of the Yale squad attempt unsuccessfully to stop this drive by Bill Bradley, class of 1965. Bradley sank 57 successive free throws as a freshman, a streak unmatched by any player—college or professional. He was the captain (and youngest member) of the gold medal–winning 1964 U.S. Olympic basketball team. The subject of the acclaimed book *A Sense of Where You Are*, by John McPhee, class of 1953, Bradley became a Rhodes Scholar, member of the NBA champion New York Knickerbockers, U.S. senator, and presidential hopeful. (Princeton University Library.)

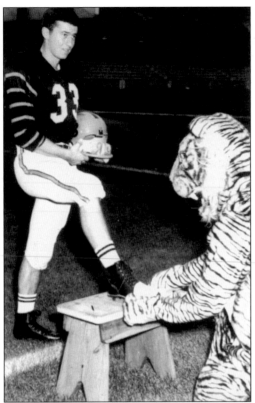

Place-kicker Charles Gogolak, class of 1966, receives an appreciative polish from the Tiger mascot while gazing appropriately into the future. A converted soccer player, Gogolak approached the football diagonally and kicked it with the inside of his foot instead of his toe. His superior innovation forever changed place-kicking in professional and collegiate football. (Princeton University Library.)

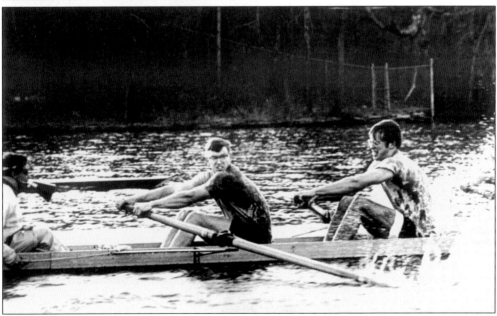

The 1969–1970 team captain and stroke Lauren Coleman (center), rower Sandy Dayton, and coxswain Bruce Millman have a ferocious crew workout. Carnegie Lake is used for training by the national rowing team, and was featured in *The Amateurs*, David Halberstam's classic book about the 1984 Olympic trials. (Princeton University Library.)

Future Olympian and American record–setter Lynn Jennings, class of 1982, leads a 1980 cross-country race. Her talents were boosted by a profound work ethic. Said Jennings, "If I'm not out there training, someone else is." (Princeton University Library.)

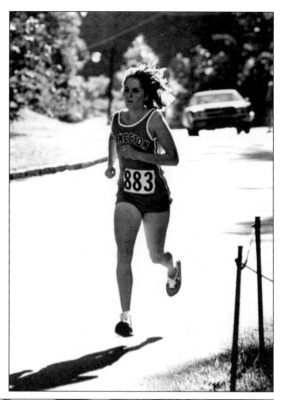

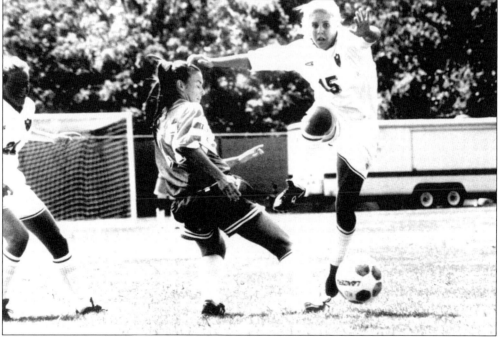

A rival soccer player gives way to a Princeton athlete in 1995. Despite Ivy League prohibitions on athletic scholarships, the university still attracts national-caliber performers. (Princeton University Library.)

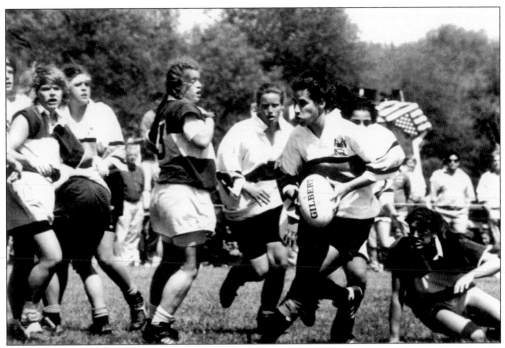

Club athletes at Princeton are as dedicated as those on official varsity teams. Here, a member of the women's rugby side breaks loose in 1995. (Princeton University Library.)

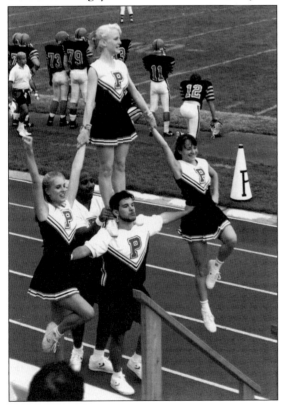

Princeton cheerleaders present a strong geometry of support for the football team and, by extension, for all of the university's competitors. (Princeton University Library.)

Seven

TRADITIONS

"FOR OLD NASSAU"

*[Cane Spree and Class Rush] weld the class together and put
some spirit into it . . . I am pulling for my class and college now
as I never did before.*

—Harrington DeGoyler Green, class of 1912.

Traditions. Every college has them and cherishes them. They create memories and bonds.
They define the very institution.

Traditions are odd and wonderful things. Most start as strange creations by the students
themselves in the face of the bewilderment, exasperation, or outright hostility of their elders.
If these rituals are popular enough to be practiced annually by succeeding classes, they
become familiar and fun and are embraced by the establishment. Thus traditions are born
with the misleading appearance of having been there all along.

Few colleges are as verdant in tradition as Princeton: its orange and black colors, tiger
mascot, the cannons on the green behind Nassau Hall, and the most festively magical
tradition of all—reunions and their glorious P-rades.

Not all Princeton traditions have survived, and some are best found only in books today.
Hazing went back nearly to the college's beginnings, with a 1764 account stating that
freshmen were forced to give "tokens of respect and subjection."

But some withered traditions deserve reseeding and cultivation. Consider the bygone
practice of composing "faculty songs." The springtime singing of these satirical ditties began
in the 1800s. The lectern did not shield from lampoon, but invited it. In 1905, for example,

singers vocalized sardonically about the newly instituted supplemental course discussion sections, known as preceptorials:

Here's to those preceptor guys,
Fifty stiffs to make us wise.
Easy jobs and lots of pay,
Work the students night and day.

Today's graduate student preceptors, required to teach in return for their stipends, might compose a sharp rejoinder about the stiff undergrads they are expected to inspire while neglecting their own work.

And what modern professor aspiring to tenure via a landmark publication would not wince at this 1927 faculty song about George McLean Harper and his book *Wordsworth's French Daughter?*

Harper went to France to get
The red-hot dope on dear Annette;
And there performed a deed of note,
Revealing Wordsworth's one wild oat.

The following chapter contains images from the first decades of the eating clubs. Of course, the clubs are dining and social organizations. However, their histories and continuities are the stuff of Princeton traditions, making it appropriate to include them here.

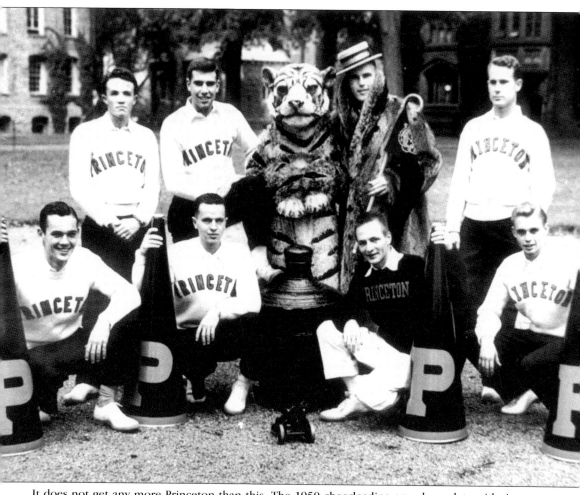

It does not get any more Princeton than this. The 1950 cheerleading squad—replete with tiger and raccoon-coated member—gathers at Cannon Green. (Princeton University Library.)

For generations, Bulletin Elm stood southeast of Nassau Hall and next to the first chapel. Even after it died, the tree served as the Web page of its era, bearing announcements nailed to its trunk. It was finally taken down *c.* 1896, during the construction of East Pyne. (Princeton University Library.)

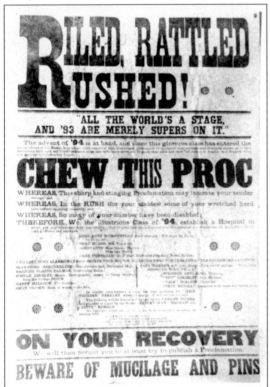

"Chew This Proc[lamation]" declared the freshman class of 1894 during the then-traditional fall hazing by the sophomores. Deftly defiant and razor wry, these 19th-century posters are prized by collectors of Princetoniana. (Princeton University Library.)

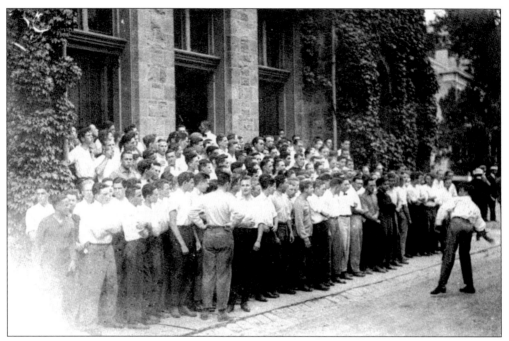

One hazing rite was the annual attempt by the sophomores to deny the freshmen entry to Dickinson Hall to hold class elections. Above, members of the class of 1913 stand shoulder to shoulder, awaiting the class of 1914. And soon the onslaught comes. Below, the freshmen charge the entrance, forcing their way into the building and into the sophomores' respect. (Princeton University Library.)

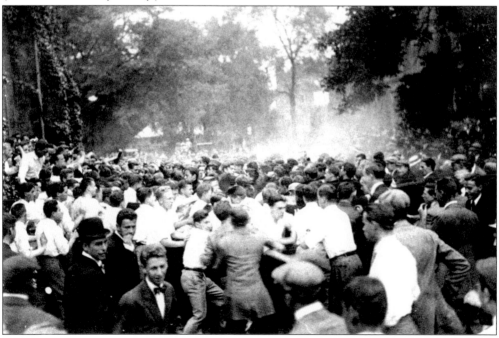

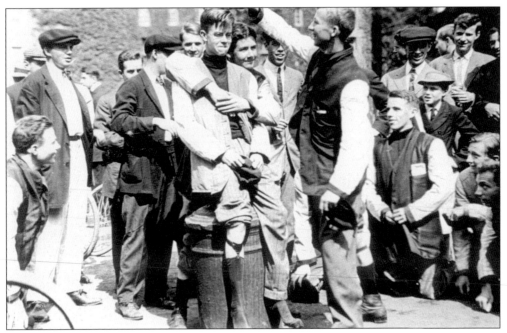

A 1920s freshman gets a hair-chopping while his garters are exposed, and manages a wan smile. But "horsing on Cannon Green" had its origins in unpleasant 18th-century ritual head-shavings of freshmen by upperclassmen. (Princeton University Library.)

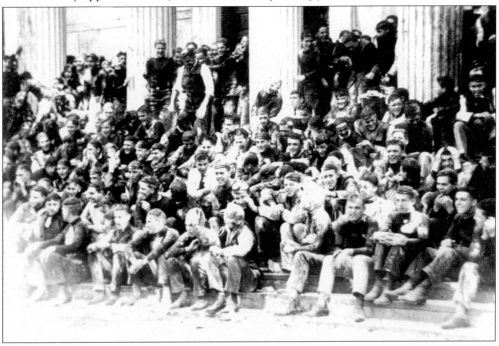

A more good-humored tradition was the "flour photo." While the freshmen posed for their class picture in front of Clio Hall, sophomores positioned on the roof above would dump flour on the underclassmen. Here, the class of 1920 laughs off its dusting in the fall of 1916. (Princeton University Library.)

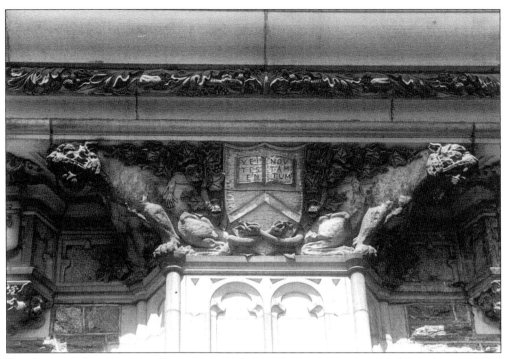

The tiger was the school's well-accepted symbol by the time the class of 1915 graduated. When that class donated the dorm that bears its name in 1949, the building's iconography prominently featured these tigers and the university crest. (Richard D. Smith.)

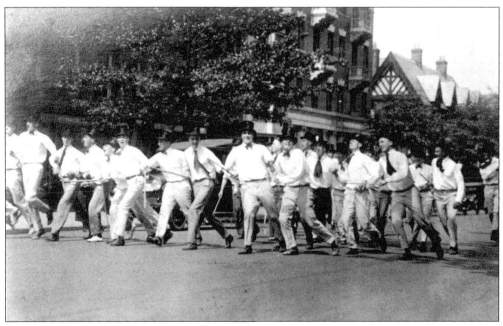

The smart-steppin' men of the class of 1920 strut their stuff on Nassau Street during the annual Junior High Hat Parade, another Princeton rite that has since vanished. (Princeton University Library.)

Food served in the college's 19th-century common dining room was notoriously bad. Students of ample means formed off-campus eating clubs as a method of culinary survival. By the turn of the 20th century, nearly three-quarters of upperclassmen belonged to such clubs. This unidentified club is enjoying a true dress-for-dinner occasion. (Princeton University Library.)

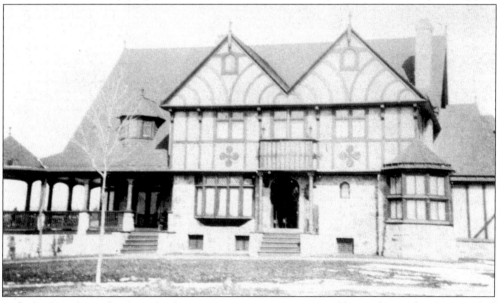

As far back as the 1840s, boardinghouses in town were patronized by students who despaired of poor college fare. Eating clubs eventually bought building lots on Prospect Street, where they constructed quarters to rival the best Princeton private homes of the day. The Tiger Inn's Elizabethan Revival accents grace this 1890s photograph. (Princeton University Library.)

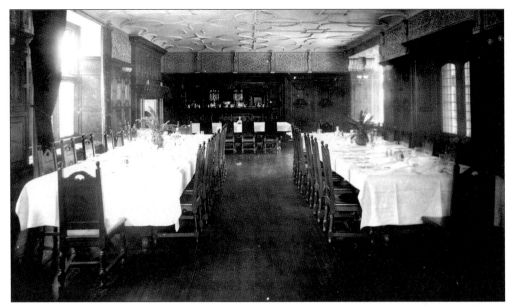

Ivy Inn, which originally rented space on Mercer Street, is believed to have been the first club to relocate to Prospect Street. Its decorous dining room demonstrates the considerable attractions of club membership.

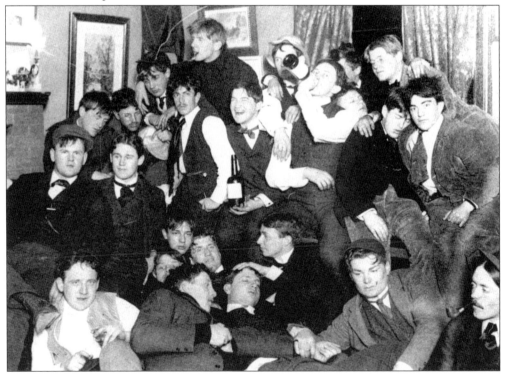

Of course, the eating clubs took on overall social functions. The trustees had allowed the clubs, provided there would be no gambling or alcohol use on site. This 1897 photograph of an unidentified, high-spirited group shows absolutely no evidence of any gambling. (Princeton University Library.)

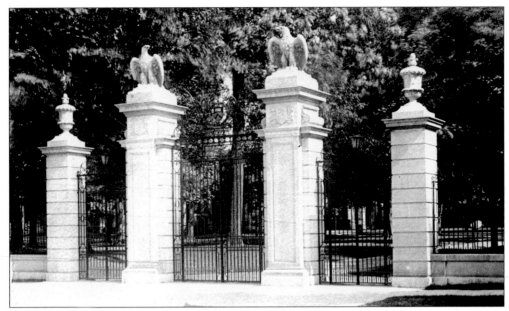

The FitzRandolph Gate was built in 1905 through the bequest of Augustus van Winkle, a descendent of Nathaniel FitzRandolph, the man who donated the first acreage for the campus. According to tradition, any student who exits through these gates before commencement day will never graduate. The gates were unlocked only during reunions until 1970, when, at the request of the graduating class, they were opened forever as a "symbol of the university's openness to the local and worldwide community." (Princeton University Library.)

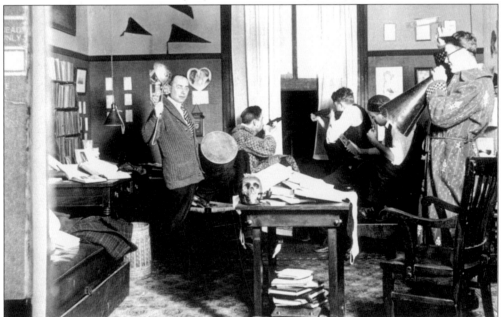

A "poler" was a humorless and endless studier. Poler's Recess was a cacophonous study break in which students campuswide leaned out their windows one spring night to bang drums, shoot fireworks, and even fire guns. Polers cut loose in this posed 1915 gag photograph, with one lovelorn roommate adding a heartbroken shot to the din. (Princeton University Library.)

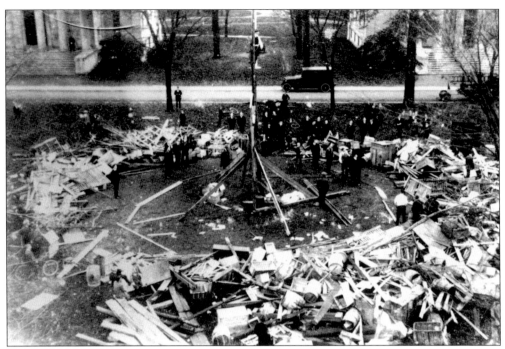

Students engineer a bonfire of monumental proportions on Cannon Green sometime in the 1920s. (Princeton University Library.)

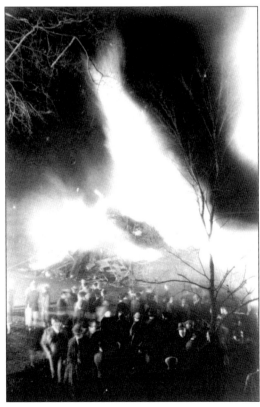

The effects of the bonfires were typically spectacular, as shown in this 1925 image. (Princeton University Library.)

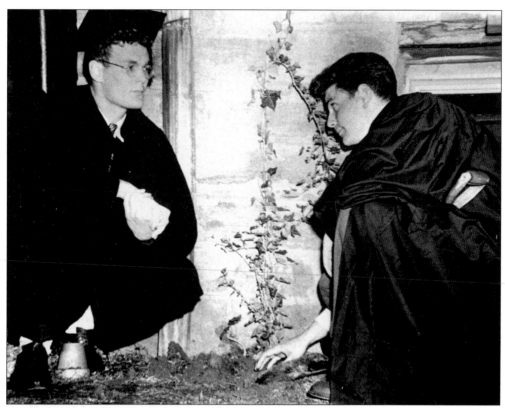

As it was only a matter of time before America's direct entry into World War II and the attendant uncertainties facing graduates, the planting of the class of 1941 ivy at Nassau Hall took on an even more-serious meaning. (Princeton University Library.)

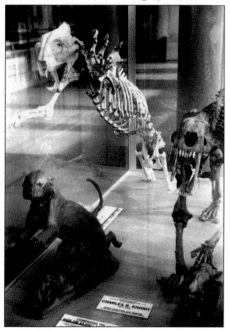

The university's mascot inspired the fascinating comparative-anatomy exhibit "The Leaping Tiger and the Saber-Tooth," a gift of the class of 1927. A modern Bengal tiger and a 28,000-year-old smilodon were mounted by renowned nature artist Charles Knight for the Guyot Hall Natural History Museum. When most of the museum's contents were removed to create office space, the tigers migrated to the Frist Campus Center. (Richard D. Smith.)

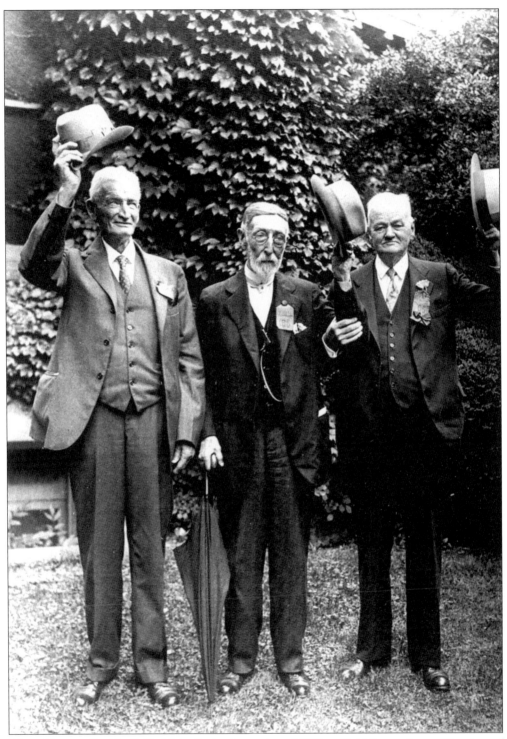

Edward Payson Rankin (left), Elisha Butler (center), and William H. Vail, members of the class of 1865, doff their hats and introduce our pages on reunions. Our hats should be off to them and all returning sons and daughters of Old Nassau. (Princeton University Library.)

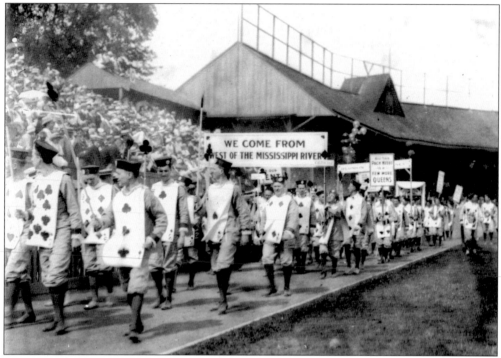

The annual reunion procession to the Prospect Street athletic fields to watch the Princeton-Yale baseball game grew into the cleverly costumed P-rade. This class's card-game theme—and the world before coeducation—inspired a sign that read, "All This Pack Needs is a Few More Queens." (Historical Society of Princeton.)

The P-rade has taken many routes over the years. Here, the class of 1909 marches up Nassau Street, probably during its 10th reunion. (Historical Society of Princeton.)

Reunions benefit not only the university but the town, as well. The vendor in this 1937 view convinces an alum that although his wares are inflated, his prices are not. (Princeton University Library.)

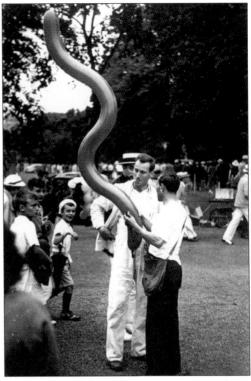

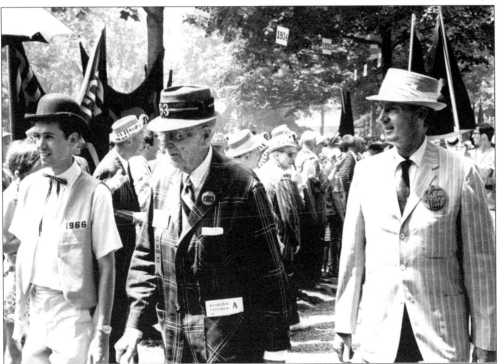

Even in a gray-scale photograph, the proud orange-and-black array of these three generations of Princetonians suggests itself. (Historical Society of Princeton.)

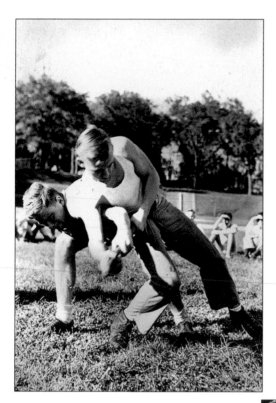

It was the sophomores of 1865 who first declared freshmen unworthy of the gentlemanly privilege of carrying a cane. After years of violent cane-snatching sprees, the school formalized Cane Spree into friendly athletic competition—including, of course, cane wrestling. Seen here, a freshman and a sophomore do battle in 1945. (Princeton University Library.)

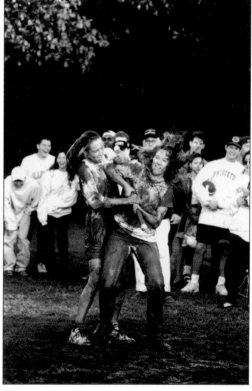

A half-century later, during the 1994 Cane Spree, two mud-smeared women show equal fighting spirit as classmates urge them on. Cane Spree now includes contests in soccer, ultimate Frisbee, and other sports. Women first entered competition when the class of 1973 took on the class of 1974. (Princeton University Library.)

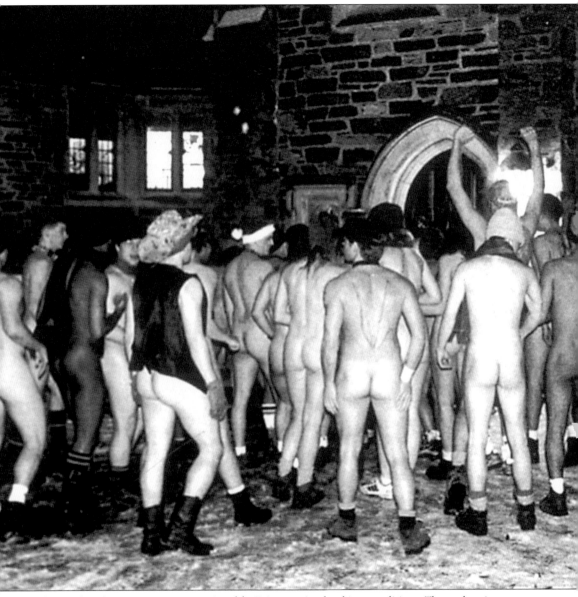

The Nude Olympics was unquestionably Princeton's cheekiest tradition. The rather innocent ritual of sophomores running unclothed in the first snows of the year began in 1970, and it certainly belied the image of Princeton as a stuffy institution. The university banned the event in 1999, not because of undress, but due to safety concerns over heavy alcohol use among participants. (*Daily Princetonian.*)

While the marching band brasses, the tiger struts, ready to embrace the next traditions of Princeton. (Princeton University Library.)

Eight

TIGERS AND TIGRESSES
1950 AND ONWARD

The streets of Princeton form lovely vistas of deep shade and glancing sunlight. Old and mossy mansions of colonial days still linger among the massive self-asserting structures of modern architecture, and old Nassau itself muses upon the changes of nearly two centuries.

—John van Cleve, writing in *The Century*, February 1887

Inevitably, Princeton's modern era is associated with Vietnam War protests and, of course, the start of coeducation. Many things changed after World War II, however, and the university was well positioned to benefit from those changes.

Princeton built upon the development of its science and technology departments. Postwar research in physics, mathematics, and the sciences in general attracted international notice. The Department of Economics was similarly respected as one of the world's best.

The 1962 building of the Engineering Quadrangle (affectionately and succinctly known as E-Quad) physically manifested the university's leadership in technology studies.

The humanities also prospered in the last half of the 20th century. The English, humanities, and history departments attracted world-renowned authors and scholars. European language studies were strong, and the university expanded its offerings in Middle Eastern and Asian languages and studies.

However, this era at Princeton is most vividly associated with the decision to begin admitting women as undergraduates. It was indeed one of the pivotal moments in the university's history.

Almost a century earlier, president James McCosh had realized that unless the school offered advanced graduate studies it would quickly fall behind the world's other colleges. Similarly, a university committee formed in the 1960s to study coeducation urged that women be admitted as rapidly as possible. Women were clearly the intellectual equal of men, the committee noted; furthermore, without women the university would not attract the best possible students, male or female. What had been unfulfilled by Evelyn College in 1897 was now fulfilled by the coeducational Princeton University of 1969.

Opponents warned that many alumni would fiercely oppose coeducation and even withhold annual donations in protest. For a time, that was indeed the case. But the university stayed the course. Today, there is no doubting the wisdom of the decision.

Moving in parallel with the admission of women was Princeton's increased attention to minority recruitment and multicultural studies. Recognizing that many excellent undergraduate candidates across a range of ethnic, religious, and social groups were coming from humble situations, the college increased opportunities for scholarships and financial assistance. The Afro-American Studies program was founded in 1969, the same year that coeducation began.

Gay, lesbian, bisexual, and transgendered students have made their presence known. Today, the school is illuminated by a diverse spectrum unimagined just a few decades before.

As Princeton continues on in the 21st century, research facilities must be developed, libraries enlarged, and new dormitories provided. The university's next great challenge will be to thrive and grow while maintaining its historic buildings and delightful vistas. Let future generations find a splendid campus in reality—not merely as wistful images in a book like this one.

As the result of a bold engineering feat in 1963, Corwin Hall (center background) was moved some 75 yards straight back from its original location on Washington Street to make room for the new Woodrow Wilson School (right). The project symbolizes Princeton's foray into the future of education and world service. (Richard D. Smith.)

During the cold war, an RKO Pathe crew set up in the Chancellor Green Library to shoot footage for the documentary series *This is America*. The episode "Letter to a Rebel," released in 1951, extolled freedom, capitalism, and, of course, American higher education. Sequences were also shot in the *Daily Princetonian* offices and in 121 Holder Hall. (Princeton University Library.)

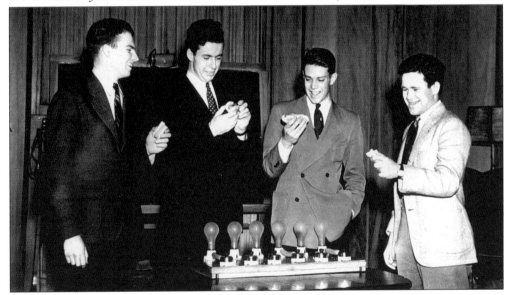

Let others trifle with building better mousetraps! Electrical engineering students savor the successful test of a device that quick-cooked hot dogs via electrocution. (Princeton University Library.)

It appears these students have received better-than-expected results in the grades posted in Alexander Hall during the spring of 1952. (Princeton University Library.)

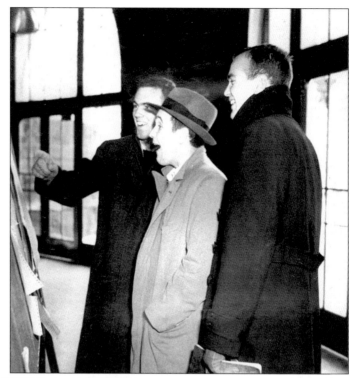

Princeton's role in post–World War II scholarship was furthered by the 1960 dedication of the John Foster Dulles Library of Diplomatic History in Firestone. Dulles (left) was a member of the class of 1908 and a pivotal secretary of state. He joins Pres. Dwight D. Eisenhower (center) and an unidentified student in examining documents. (Princeton University Library.)

Spring riots were a perennial, if not a particularly proud, occurrence during the 1950s and 1960s. Proctors and police usually quelled the hijinks—such as this Volkswagen-rocking episode in Palmer Square—before serious damage was done. (Princeton University Library.)

Sabra Follett Meservey became Princeton's first female doctoral candidate when she entered the Oriental Studies program in 1961; she graduated in 1966. Tsai-ying Chang's 1964 doctorate in biochemistry was the first Ph.D. granted to a woman by the university. Their diplomas were written in proper Latin but used masculine pronouns—a gaffe that the school later corrected. (Princeton University Library.)

Astrophysicist Lyman Spitzer (1914–1997) was skiing on a brilliantly sunny day in Switzerland in the late 1940s when he had a scientific epiphany: It should be possible to re-create the fusion reactions that power the sun and stars as a cheaper, safer alternative to nuclear fission. In 1951, a government-funded project—aptly code-named Project Matterhorn—was organized at Princeton, and was the forerunner of today's Princeton Plasma Physics Laboratory at the university's Forrestal Campus. Spitzer is pictured with the stellarator he donated to the Smithsonian in 1983. He may be smiling at how the current-generation experimental fusion reactors dwarf this early desktop device in size and sophistication. (Princeton Plasma Physics Library.)

The tower of Fine Hall, built in 1968, is a discreet campus landmark. Situated on the slopes of the lower campus, it does not rival Holder Tower in the town skyline. The complex was named for Henry Burchard Fine (1858–1928), who helped Woodrow Wilson raise Princeton's science and academic standards. (Richard D. Smith.)

In addition to protesting U.S. military actions in Indochina, some activists questioned the university's ongoing contracts with the Department of Defense and its ties to the Institute for Defense Analysis (IDA). A prolonged sit-in around the IDA offices in 1970 became as much a counterculture festival as a political event and ended peacefully. (Princeton University Library.)

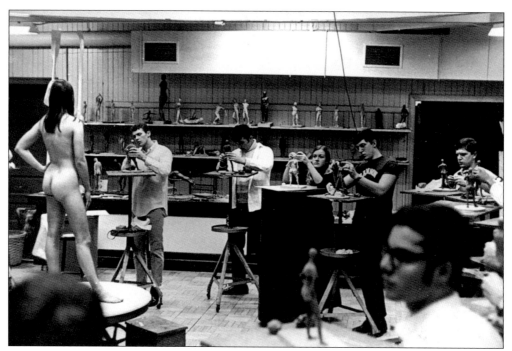

The maturity with which coeducation was handled by the first mixed classes is proven by the unselfconscious students in this sculpture class, totally engrossed in their learning and the creative process. (Princeton University Library.)

Singer, songwriter, and American music legend Bob Dylan grins after accepting an honorary degree. Commencement in 1970 coincided with a cacophonous hatch of the 17-year locusts (actually, cicadas), an event later commemorated by Dylan in "Day of the Locusts." (Princeton University Library.)

A student tutor of the 1970s intently shares the adventure of learning with a young girl. Student volunteers contribute to area communities in many ways. (Princeton University Library.)

Jacinto Aria, graduate school class of 1974, of the Department of Anthropology, examines a Mayan conch shell at the Scheide Library. Indigenous American and Latino students have studied at Princeton for most of its history, including Jacob Wooley, a Delaware Native American and member of the class of 1762; and Jose Romero and Enrique Ybanez of Mexico, members of the class of 1843. (Princeton University Library.)

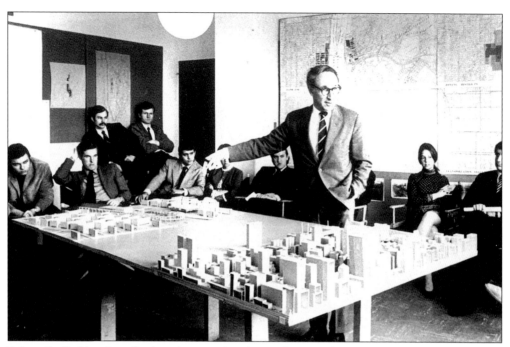

Robert L. Geddes (standing) makes a point about planning during a session at the Princeton University School of Architecture's Urban Studies studio in New York City. Off-campus study programs became increasing popular and successful in the 1970s. (Princeton University Library.)

Shown here are students at course signup in the 1980s, the era before Internet registration and a time when it was very hip to wear T-shirts from other colleges. (Princeton University Library.)

From agitator to commentator, Sally Frank, class of 1980 (right), participates in a 1989 conference entitled "20 Years of Coeducation." As a student, Frank brought suit against the male-only eating clubs, arguing that women should have full access to campus opportunities. The clubs held that as private organizations they should be allowed to limit membership. Changing attitudes have since led all Princeton eating clubs to become fully coed. (Princeton University Library.)

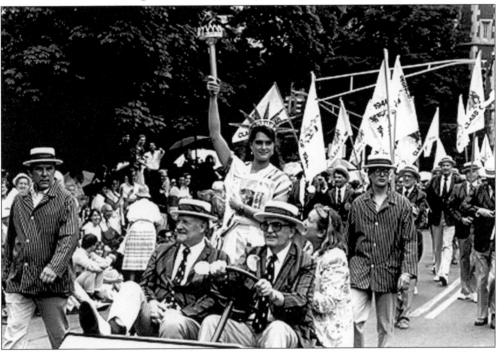

Carrying the torch, Brooke Shields joins old-guarders in the 1985 P-rade. Already an internationally famous actress when admitted to Princeton, Shields won respect as a hard worker and a friendly classmate who insisted on being treated as just another student.

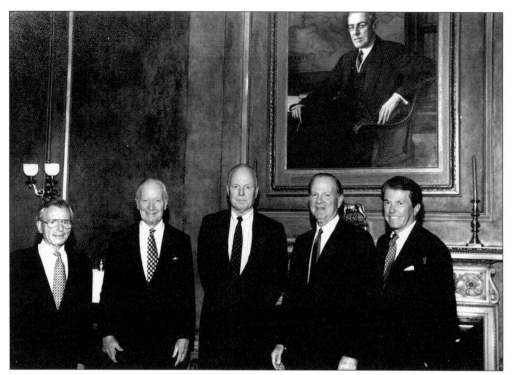

One of Princeton's highest honors is the Woodrow Wilson Award, given annually to an alum whose career has been "in the nation's service." On the occasion of receiving the award in 1996, former treasury secretary James A. Baker III, class of 1952 (second from right), was joined by classmates Frank Carlucci (far left), Craig Nalen (center), and William Hawley (far right), as well as Russell Train, class of 1941 (second from left). (Princeton University Library.)

In her senior thesis, Wendy Kopp, class of 1989, developed a concept in which recent college graduates would commit to two years of teaching disadvantaged youngsters. The result was the highly successful Teach for America program. In 1993 Kopp became the first woman to win a Woodrow Wilson Award. (Teach for America.)

The late 20th century saw increased honors for Princeton's faculty. Novelist Toni Morrison, a Council of the Humanities professor, was awarded a Pulitzer Prize in 1988, a Nobel Prize in 1993 (shown here), and a National Humanities Medal in 2000. (Princeton University Office of Communications.)

The theories of mathematician John Forbes Nash, graduate school class of 1950, led to a 1994 Nobel prize in economics. His triumphs and his struggle with schizophrenia were chronicled in the biography *A Beautiful Mind*, by Sylvia Nasar. Here, Nash confers with actor Russell Crowe (center) and director Ron Howard (right) during on-location shooting for the Academy Award–winning movie version in 2001. (Ron Howard Productions.)

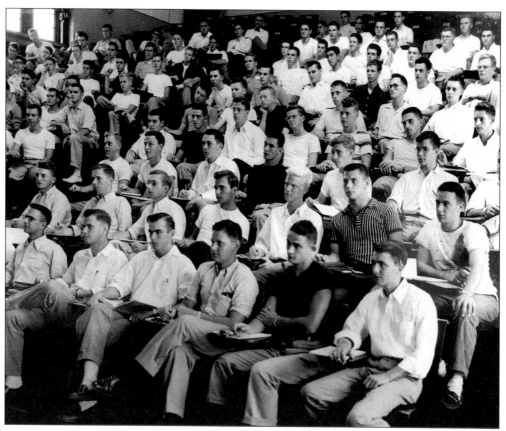

Students in a 1952 freshman engineering lecture (above) were serious, dedicated, and talented. No less so were the chemical engineering students (below) touring a Union Camp facility in 1997. But the latter group reflects the many new faces of Princeton, as diverse as the learning and life experiences that await them. (Both photographs: Princeton University Library.)

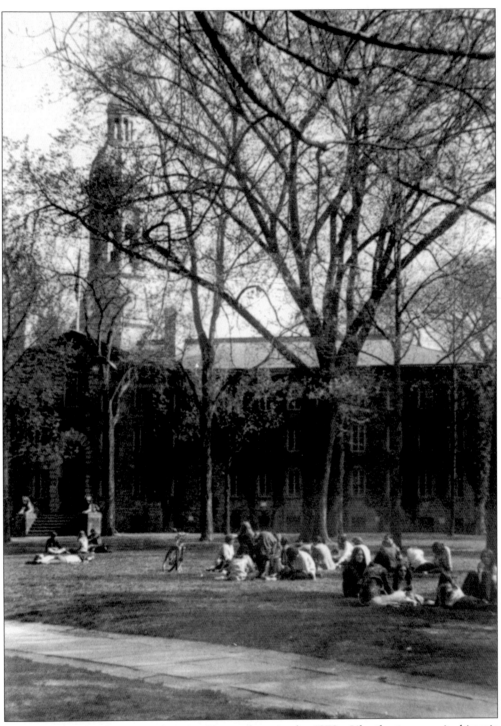

Students study on the ever-welcoming Nassau lawn in the 1970s. Like the trees on its historic campus, Old Nassau will forever shelter its own. (Princeton University Library.)